From the Library of

To Lee

Merry Christmas 1980

Love,

Essie

William Merritt Chase

To Lee

Merry Christmas 1980

Love,
Essie

William Merritt Chase

By Ronald G. Pisano

WATSON-GUPTILL PUBLICATIONS, NEW YORK

First published 1979 in the United States and Canada by Watson-Guptill Publications,
a division of Billboard Publications, Inc.,
1515 Broadway, New York, N.Y. 10036

Library of Congress Cataloging in Publication Data
Pisano, Ronald G.
 William Merritt Chase.
 Bibliography: p.
 1. Chase, William Merritt, 1849-1916. 2. Painters
—United States—Biography.
ND237.C48P57 759.13 [B] 79-13532
ISBN 0-8230-5739-9

Manufactured in Japan.

First Printing, 1979

Acknowledgments

This book is a partial result of six years of research on William Merritt Chase. The research began as a graduate thesis on Chase's students, which served as the basis for a two-part 1973 exhibition, "The Students of William Merritt Chase," sponsored jointly by the Heckscher Museum in Huntington, N.Y., and The Parrish Art Museum in Southampton, N.Y. Several articles on Chase and his teaching career followed; and in 1976 I arranged a comprehensive exhibition of 108 Chase works, held at M. Knoedler and Company in New York.

After doing my work on Chase's students, I realized the lack of recent research on Chase's own art and took on what would be the long and arduous task of compiling a catalogue raisonné. The cataloguing of these works of art was complicated by the fact that Chase was a prolific artist who kept no record of his artwork. Also, many unsigned works by his pupils have since had false Chase signatures added to them. These problems are now being resolved, however, through a computerized catalogue, which will allow as well for greater flexibility than is provided by a standard printed catalogue raisonné. Additions to it and corrections can be made continually and easily as new information is made available and as paintings change hands. Other benefits of this computerized format are being discovered through further experimentation.

Since this computerized catalogue raisonné, the first such compilation of an artist's complete oeuvre, will serve mainly as a research tool, I am especially happy to have this opportunity to write a monograph on Chase, featuring a broad selection of his work and directed to the general public. Selecting the works of art to be included was a difficult task; the selection here is, in effect, intended to represent a broad spectrum of this versatile artist's work. I am particularly grateful to Dorothy Spencer, who suggested that I write this book and provided me with the occasion to do so.

During the general course of my research, I have benefited from the advice and assistance of innumerable people, including scholars, museum personnel, collectors, art dealers, and especially the dedicated staffs of the Art Division and Print Room of the New York Public Library, the Frick Art Reference Library, and the Archives of American Art. Although it is impossible to acknowledge all of these people individually, I would like to express my sincere gratitude to all who have assisted me over the past six years. I must also single out and thank several colleagues for their continuous help and scholarly contributions: Doreen Bolger Burke, Lois Dinnerstein, David Kiehl, William Gerdts, Abigail Booth Gerdts, Robert Preato, Bruce Weber, Barbara Weinberg, and Graham Williford. Art galleries have also been extremely cooperative and supportive, including A.C.A. Galleries (Dennis Anderson), Berry Hill Galleries, Inc., Chapellier Galleries, Inc. (Irene Little and Pat Eargle), Coe-Kerr Gallery, Inc., Davis and Long Gallery, Inc. (Roy Davis and Cecily Langdale Davis), Graham Gallery, Grand Central Art Galleries, Hammer Galleries, Hirschl and Ad-

ler Galleries, Inc., Kennedy Galleries, Inc. (Deedee Wigmore), M. Knoedler and Co., Kenneth Lux Gallery, Kraushaar Galleries, Newhouse Galleries, Inc. (Clyde Newhouse), Schweitzer Gallery, Robert Schoelkopf, Sotheby Parke Bernet, Inc. (Grete Meilman and Peter Rathbone), and Ira Spanierman, Inc.

I am also grateful for the patience and kind cooperation of the many collectors who have responded to my requests for information about their works of art by Chase. Among these collectors who share my enthusiasm for Chase's work, I would like to express my special thanks to Raymond and Margaret Horowitz, who have been a continual source of inspiration, and to Dr. Robert Coggins, JoAnn and Julian Ganz, Jr., and Margaret Mallory. Jackson Chase Storm (William Merritt Chase's grandson) and Arthur and Irma Zigas (present owners of the Chase homestead in Shinnecock Hills) have also been encouraging and particularly supportive.

Those Chase students I have been able to interview have given me a very special and personal insight into the character of this artist, as well as a better understanding of his teaching methods. I am grateful to Georgia O'Keeffe for providing me with an account of her early days as a Chase student. Ethel Paxson DuClos has also been extremely helpful in describing her experiences at the Pennsylvania Academy of the Fine Arts, where she studied with Chase, and in providing additional information about her colleagues. Other artists who studied under Chase and have shared their remembrances with me include Caroline Van Hook Bean, James H. Daugherty, Harriet V. C. Ogden, Helen Lee Peabody, and Helen Appleton Reed.

Two museum directors deserve warmest thanks: Eva Ingersoll Gatling (former director of the Heckscher Museum), who provided me the chance to organize my first Chase-related exhibition, and Jean Weber (director of The Parrish Art Museum), who has continually promoted my Chase research. I am especially grateful to The Parrish Art Museum for helping to support my continuing research on Chase and for sponsoring my computerized catalogue raisonné and to Robert Chenhall and Carole Rush for their assistance with this project. The William Merritt Chase Archives, which I established at The Parrish Art Museum in 1977, have also served as a valuable source of photographs documenting Chase's life.

Anyone writing about Chase is indebted to the work of previous Chase scholars, including, most notably, Chase's original biographer Katherine Metcalf Roof and two subsequent Chase scholars—Wilbur Peat and Ala Story.

Finally, I would like to thank those at Watson-Guptill who have contributed to publication of this book; D. Frederick Baker, who read the manuscript and offered invaluable advice; and David Cassedy, who edited the initial manuscript and helped me to express my thoughts more clearly.

List of Plates

Chronology

1849 William Merritt Chase born November 1, at Williamsburg (later renamed Nineveh), Indiana, the first of seven children born to David Hester Chase and his wife, Sarah Swaim Chase].

1861 The Chase family (now including two additional children, George and Amanda) moves to Indianapolis, where David [Hester] Chase, in partnership with Adelbert C. Dawes, opens a shoe store [known as the New York Boot and Shoe Store.]

1865/1866 William Merritt Chase begins drawing, producing likenesses of his family and friends.

1867 David Chase takes his son William to a local portrait painter, Barton S. Hays, for his first professional art instruction.

1868 William Merritt Chase enlists in the U.S. Navy but, after three unhappy months as a sailor on the training ship *Portsmouth* in Annapolis, returns home.

1869 Resumes study with Hays; then, prompted by Hays and another local artist, Jacob Cox, David Chase sends his son to New York for further art studies with Joseph O. Eaton. He moves into Eaton's studio while the New York artist travels to Europe, and enters the classes at the National Academy of Design. About this time, father's business fails and Chase family moves to Franklin, Indiana, and then to St. Louis.

1870 Moves to his own studio in the YMCA building on East 23rd Street, New York, and supports himself by painting still lifes.

1871 Exhibits three works (*Blue Plums, Catawba Grapes* and *Portrait*) at annual exhibition of the National Academy of Design. Visits his family in St. Louis and, while there, shares a studio with James W. Pattison. Meets John Mulvaney, a local artist just returned from studies in Munich. Attracts attention of prominent St. Louis businessmen, who raise $2,100 to send him for study abroad, in Munich.

1872 Enters Royal Academy in Munich in the fall, receiving instruction there from Alexander von Wagner and Karl von Piloty. Becomes friends with Frank Duveneck, Walter Shirlaw, and J. Frank Currier.

1874 Paints *The Dowager* and sends it to his St. Louis patron W. R. Hodges as partial fulfillment of obligations to his sponsors.

1875 Paints *Keying Up—The Court Jester*. Hodges sends *The Dowager* to New York for exhibit at National Academy of Design, where it is purchased by prominent artist Eastman Johnson.

1876 *Keying Up—The Court Jester* exhibited at Centennial Exhibition in Philadelphia (lent by S. M. Dodd), awarded a medal, and acclaimed by critics.

1877 Paints *Ready for the Ride*, purchased by prominent American art collector Samuel P. Avery. Exhibits three works at Interstate Industrial Exposition in Chicago (*Flower Girl, Unexpected Intrusion, Keying Up*).

1877-1878 Travels to Venice with Frank Duveneck and John H. Twachtman and, while there, receives invitation to teach at Art Students League in New York.

1878 Returns to Munich, then refuses a teaching position at Royal Academy there. Moves to New York to accept teaching post at Art Students League. Becomes member of Society of American Artists, with whom his painting *Ready for the Ride* is shown to critical approval. Acquires coveted Tenth Street studio, artistic citadel of the city, where he also teaches private classes. Joins Tile Club.

1879 Exhibits with American Watercolor Society and continues to do so intermittently during 1880-1894.

1880 Elected president of Society of American Artists (serves one year). Travels with Tile Club up Hudson River and Northern Canal to Lake Champlain. About this time, meets Alice Gerson in New York, who agrees to serve as his model and after six-year courtship consents to marriage. Also meets artist Robert Blum, who becomes lifelong friend and close artistic associate.

1881 Travels with Tile Club to eastern Long Island, where he paints *A Subtle Device*, a clever self-portrait depicting the artist painting in an open-air setting, directly from nature like the pleinairists. Makes first trip to Spain, with J. Carroll Beckwith, Robert Blum, Herbert Denman, and Abraham A. Anderson. Goes on to Paris, where his portrait of friend Frank Duveneck *The Smoker* had received honorable mention at Paris Salon. While there, meets Belgian artist Alfred Stevens, who praises Chase's work but suggests he abandon his "Old Master" style. Admires work of Manet and convinces J. Alden Weir to purchase two Manet paintings (*Girl with a Parrot* and *Boy with a Sword*) for client Erwin Davis.

1882 Returns to Spain, accompanied on ocean crossing by Blum, Beckwith, Arthur Quartly, Ferdinand Lungren, and Frederick Vinton. Stops first in Paris, where Chase's *Portrait of Peter Cooper (The Burgomaster)* is exhibited at the Salon. Goes on to Madrid with Vinton and Blum. Later re-

turns to France, where he meets Giovanni Boldini, and then visits Holland before returning home. With Blum, forms Society of Painters in Pastel. Exhibits with Philadelphia Society of Artists. Exhibits his earliest-known monotype at Salmagundi Club's ("black-and-white art" exhibition).

1883 Traveling to Europe with Frederick Freer, meets H. Siddons Mowbray aboard ship. Visits Madrid again. His painting *The Smoker* exhibited at Munich Exposition. About this time, becomes a member of Arts Club, an informal group of liberally minded artists headed by Charles Henry Miller. *Portrait of Peter Cooper* destroyed in fire at Lotos Club. Plays important role in organizing Pedestal Fund art loan exhibition in New York and is active member of committees. Also lends generously objets d'art from his own collection to show.

1884 Completes *Portrait of Miss Dora Wheeler*, exhibited at Paris Salon along with his painting *Young Girl Reading*. Exhibits seventeen works in "Initial Exhibition of Painters in Pastel" (March 17-29) at W. P. Moore Gallery in New York. Visits Blum in Holland and paints *A Summer Afternoon in Holland* (or *Sunlight and Shadow*), depicting friend Blum in his garden.

1885 Elected president of Society of American Artists (serves for ten years). Visits London, where he meets James Abbott McNeill Whistler; stays on longer than intended, to paint mutual portraits. Chase completes his portrait of Whistler, but Whistler's of Chase is never completed. Travels to Antwerp to see work of Alfred Stevens and Jules Bastien-Lepage at International Exhibition, then to Haarlem and Amsterdam. Whistler accompanies him on this trip, during which they have a falling-out.

1886 Begins series of small landscape and marine paintings in and around Brooklyn and New York. First one-man exhibition of 133 works held at Boston Art Club (November 13-December 4) includes his portrait of Whistler and is well received by critics. Marries Alice Gerson, who is then about twenty years old (Chase is thirty-seven).

1887 Auction and loan exhibition of Chase work at Moore Gallery, New York (March 2-3), including 98 works for sale and 25 works on loan (a financial disaster, grossing only $10,000); several major works, including *A Summer Afternoon in Holland*, are "bought back." His first child, Alice Dieudonnée, is born.

1888 Second exhibition of Painters in Pastel, at Wunderlich Gallery (May). Second child, Koto Robertine, born.

1889 *Portrait of Mrs. C.* (or *Portrait of a Lady in Black*) awarded a second-class medal at Exposition Universelle, Paris. Third exhibition of Painters in Pastel held at 278 Fifth Avenue (formerly Hazeltine Galleries in May. First son, William Merritt, Jr., born.

1890 Last exhibition of Painters in Pastel, at Wunderlich Gallery, New York (May 1-24). Carmencita dances at Chase's Tenth Street studio, with social arrangements made by John Singer Sargent and wealthy partoness Mrs. Jack Gardiner of Boston; shortly after, Chase paints portrait of the Spanish dancer. Visits Mrs. William Hoyt in Southampton to discuss possibility of opening a summer art school at nearby Shinnecock Hills. Elected to full membership in National Academy of Design. Paints scenes of New York's Central Park.

1891 Shinnecock summer art school opens, with Chase as director and principal teacher (through 1902). Auction of his work (67 paintings and pastels) at Fifth Avenue Art Galleries, New York. Though highly praised by critics, works once again bring disappointingly low prices. Two-year-old William Merritt, Jr., dies.

1892 Summer home at Shinnecock Hills (designed by Stanford White) completed. Family joins him there, and for each successive summer, while he teaches his art class nearby. Appointed to advisory committee of 1893 World's Columbian Exposition in Chicago. Exhibits four works in Munich Crystal Palace exhibition.

1893 Paints *Portraits of Mrs. C. (Lady with a White Shawl)*.

1894 Exhibits *Portrait of Mrs. C.* at Pennsylvania Academy of the Fine Arts annual exhibition; shortly afterward it is purchased for the Academy.

1895 Resigns presidency of Society of American Artists. *A Friendly Call* is awarded Shaw Fund Prize at Society of American Artists' exhibition. Reputedly because of financial troubles, decides to give up Tenth Street studio and dispose of its contents at public auction (early in 1896). About this time, purchases home on Stuyvesant Square, New York, which remains his residence until his death in 1916.

1896 Auction (January 7) at American Art Galleries, New York, including contents of Tenth Street studio and 66 of his own works of art. Despite generous presale publicity, gross receipts are barely $21,000. Highest price offered for one of Chase's own paintings, *The Old Road to the Sea*, is mere $610. Escorts art class to Madrid. Returns and resigns teaching posts at Brooklyn Art School and Art Students League; opens his own school (The Chase School of Art) in New York that autumn. Also accepts teaching position at Pennsylvania Academy of the Fine Arts, traveling to Philadelphia weekly to conduct class.

1897 Important one-man show at Art Institute of Chicago (November 23-December 26), comprised of 71 of his works. Also teaches there for a term (1897-1898).

1898 About this time, withdraws from managing the Chase School of Art, which then becomes New York School of Art. Remains at the school as head instructor until 1907.

1900 Short trip to Europe; visits Paris, where his painting *Portrait of Mrs. C.* is awarded a place of honor at Exposition Universelle.

1901 *Portrait of a Lady with a Rose (Miss M.S. Luken)* awarded Temple Gold Medal at Pennsylvania Academy of the Fine Arts. *Idle Hours* awarded gold medal at South Carolina Interstate and West Indian Exposition, Charleston (1901-1902). Paints *Dorothy and her Sister*, later chosen for purchase by French government for Luxembourg Palace in Paris (but deal is never consummated owing to outbreak of World War I).

1902 Travels to London to pose for a portrait by John Singer Sargent, commissioned by his pupils and intended as gift to the Metropolitan Museum of Art. Final summer of Shinnecock summer art school.

1903 Travels to Europe with summer class. Visits John Lavery and Frank Brangwyn in London and goes on to Paris, where he visits with Roland Knoedler and Alexander Harrison. Then proceeds to Munich to see Secession exhibition and visits with old friends. There meets two former students, Henry Rittenberg and Eugene Paul Ullman. Also visits Franz von Lenbach and Carl Marr, as well as Franz Ritter von Stuck. Goes on to Berlin and Holland, where he teaches a summer class and visits Joseph Israels.

Hears of Whistler's death and, along with his class, sends a mourning wreath.

1904 Teaches summer class in England and takes his students to studios of Sargent, Lavery, Brangwyn, Edwin Austin Abbey, Lawrence Alma-Tadema, and John James J. Shannon. In London paints his famous still life *An English Cod*, shortly afterward purchased by Corcoran Gallery of Washington, D.C. Mary Content, his youngest daughter, born.

1905 Holds European summer class in Madrid and takes students to visit house and studio of Joaquin Sorolla. Stops in London and Paris. Exhibits three works at Munich Crystal Palace exhibition. One-man exhibition at McClees Gallery in Philadelphia (41 works), transferred on lesser scale to Vose Gallery in Boston.

1906 Spends summer months at home in Shinnecock Hills, Long Island.

1907 Travels to London and Paris and then on to Italy, where he spends time in Venice and teaches summer class in Florence. Purchases villa in nearby Fiesole and while there, visits George De Forest Brush and Julius Rolshoven. Last year of teaching at New York School.

1908 Returns to Italy without students and is commissioned by Italian government to paint self-portrait for Uffizi Gallery. Elected member of Academy of Arts and Letters in New York. Resumes teaching at Art Students League.

1909 Conducts summer art class in Florence. One-man exhibition at Vose Gallery, Boston. Traveling exhibition of 56 of his works visits major U.S. museums. Last year of teaching at Pennsylvania Academy of the Fine Arts. Takes students to see major Sorolla exhibition at Hispanic Society in New York.

1910 Receives Grand Prize at Exposición International de Bellas Artes in Santiago, Chile, where he exhibits *Fish* and *Portrait of Mrs. C.* Important retrospective of 142 works at National Arts Club, New York. Holds summer class in Florence and paints at his Fiesole villa. Visited by Irving Wiles and also see vacationing Beckwith and his wife.

1911 Visits London and Paris and then holds summer class in Florence. Final year of teaching at Art Students League. Exhibits three paintings (*His First Portrait, Cod and Snapper,* and *Dorothy and Her Sister*) at Roman Art Exposition.

1912 His portrait *Mrs. H.* is awarded Thomas R. Proctor Prize at National Academy of Design Winter Exhibition. European trip to London and Paris, where Mrs. Chase and son Dana accompany him to Futurist exhibition. Also visits Gaston La Touche. Proceeds to Holland and Bruges, where he holds summer class and paints several notable still lifes, including *Still Life: Fish,* Brooklyn Museum and *The Belgian Melon.*

1913 Visits Armory Show in New York, in which many former pupils have works represented; his own work purposely excluded. Heartily disapproves of modernist tendencies. Last European summer class held in Venice. While in Venice, visits artist Emma Ciardi, whose work he admires, and also calls on Julius Rolshoven and Mariano Fortuny's widow. *Dorothy and Her Sister* purchased for the Luxembourg.

1914 Trip to London in spring; visits Brangwyn, Shannon, Sargent, and Alexander Harrison. Summer class at Carmel-by-the-Sea, California (his last summer class), where he resumes making monotypes.

1915 Commissioned to paint self-portrait for Richmond Art Association, Richmond, Indiana. Serves on Art Committee for Panama-Pacific Exhibition, San Francisco, and returns to California to arrange major display of 32 of his works at this international exhibition.

1916 Traveling one-man exhibition visits Detroit and Toledo museums. Because of failing health, travels to Atlantic City to regain strength during the summer. Returns to New York, where he dies shortly afterward (October 25th) at his home on Stuyvesant Square.

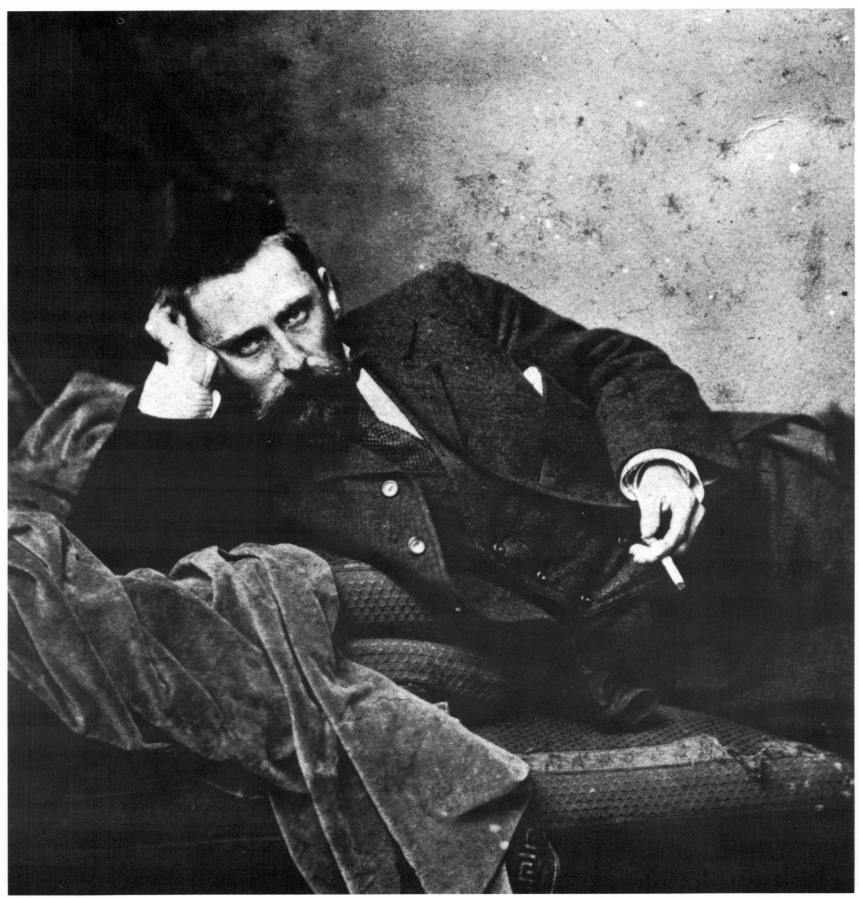

William Merritt Chase, c. 1878.

Introduction

WITH THE GROWING AWARENESS and reassessment of the importance of nineteenth- and early twentieth-century American art, William Merritt Chase (1849–1916) has emerged as a quintessential American artist. Not only did he champion the cause of American art and American artists, he also sought to establish an American art statement. The work he produced is now recognized as a synthesis and summation of the many divergent art movements current at the turn of the century. Chase considered himself a "realist." The broad scope of his work, however, precludes simple classification. Included in his oeuvre are works of great power and dynamism, as well as quiet, sensitive paintings with delicate nuances of character. He was acutely aware of artistic developments both in this country and abroad, and in his mercurial way he adopted stylistic elements from almost every artist worthy of attention. As a teacher of art, Chase instructed his pupils to do likewise, counseling them: "Be in an absorbent frame of mind. Take the best from everything." [29, p.434]* Through careful selection and clever amalgamation, he managed to create a composite style of his own, which has been described as eclectic but which is clearly recognizable as the "style of William Merritt Chase."

Commenting on the character of Chase's work, a contemporary critic wrote: "The national style, so far as there can be any American style, is a composite, blending indistinguishably the influence of old and new schools of painting. In a certain sense, Mr. Chase is a typical American artist . . . moreover, he is sane, unsentimental, truthful and unpretentious. All these are typical American qualities so far as our painters are concerned." [23, p. xxix] Other critics of the period also recognized the distinctive American character of Chase's work. One who linked his work to that of Sargent described the particularly American aspect of their art as "the nervousness, crispness, intensity of

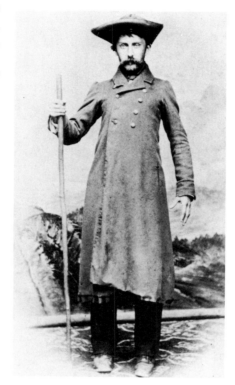

(Top) The artist in peasant costume for the Munich Ball, c. 1875. (Bottom) The artist in costume, Munich, c. 1876.

American life."[1] At Chase's death in 1916, he was proclaimed ". . . more than any other, a representative American artist." [6, p. 537]

Unfortunately, after his death, the distinctively American character of his work, which was so easily discerned by contemporary critics, was soon obscured by the obstreperous nature of subsequent movements. As the "Ashcan" school came into favor, only that which was unseemly and downtrodden was considered "American." It is interesting that Chase referred to these artists as "depressionists," since their statement (with some revisions) was resurrected during the years of the great Depression under the guise of "social realism," "Fourteenth Street genre," and other such classifications—again emphasizing hardship and deprivation. Although the initial impact of their style was soon blunted by a growing interest in abstract "modernism," works by these artists are still used as examples of archetypical American art. But the mantle of "typical American art" does not rest easily on the narrow vision of these artists. Also, the definition itself is based simply on subject matter, without regard, in many instances, to quality. In truth, we are still grasping for an "American identity" in the art of the past—so much so that we often overlook quality.

Artists like Chase, who cannot be placed any more easily in the "American camp" with Eakins, Homer, Ryder, and company than among the expatriates Whistler, Cassatt, and Sargent, are left precariously suspended in midair, to be dealt with at some later date. Only within recent years is Chase's art being seriously reevaluated, its reappraisal prompted in part by its dramatic increase in monetary value. Chase himself realized that Americans value that which is costly; he instructed his pupils to place high prices on their works if they wanted them to be considered seriously. Although there have been a number of art historians, critics, and dealers who believed in and promoted Chase's work, ultimately the general public is largely responsible for the Chase revival. People are beginning to disavow the myths defining what is

*Please note: bracketed numerals refer to sources found in the Bibliography and their respective page numbers.

American in American art and are looking at the art itself. Certainly, the quality of Chase's art speaks for itself and needs no spokesman.

WILLIAM MERRITT CHASE was born November 1, 1849, in Williamsburg (later renamed Nineveh), Indiana. He was one of seven children of Sarah Swaim and David Hester Chase.[2] It is recounted that, as a boy, he showed a marked ability in drawing and painting; and when the family moved to Indianapolis in 1861, this burgeoning talent was nurtured by Barton S. Hays, a local artist.[3] After intermittent study with Hays and an unhappy three-month stint at the U.S. Naval Academy in Annapolis, Chase was determined to pursue a career as an artist. Although his practical father, who was proprietor of the largest shoe store in Indianapolis, was displeased, another local artist, Jacob Cox, convinced the elder Chase to send his son to New York for further art studies. At age twenty, in 1869, Chase prepared to leave for the East Coast with a letter of introduction from Hays to Joseph O. Eaton, a New York portrait artist. In New York Chase studied with Eaton and in the classes of the National Academy of Design, working first in Eaton's temporarily unoccupied studio and then in a studio of his own located in the YMCA Building on East 23rd Street.

Shortly after Chase arrived in New York, his father notified him that the family business had failed and that he could no longer support his son's art training. Eaton, who recognized the young artist's talent but also realized it was unlikely that the unknown Chase would get any meaningful portrait commissions in New York, suggested he support himself by painting still lifes, which were more easily sold. Apparently this suggestion was accepted by Chase and enabled him to continue his studies in New York.

In 1871 two of his still lifes (*Blue Plums* and *Catawba Grapes*), as well as one of his portraits, were accepted for the spring exhibition of the National Academy of Design. Despite this encouraging recognition, Chase left that year for St. Louis, where his family had resettled. There are various possible reasons why Chase left New York: his father was still in financial difficulty; the young Chase was unhappy with the instruction at the National Academy of Design School (where an emphasis was placed on drawing rather than on painting); or there was also a better chance of obtaining portrait commissions outside New York.

Aside from his completing a number of competent still-life paintings and a few uninspired portraits of local citizens, the year Chase spent in St. Louis (1871) proved critical in redirecting his artistic development. While in St. Louis, he shared a studio with James William Pattison, where he met John Mulvaney, an artist who had recently returned from studies abroad. Mul-

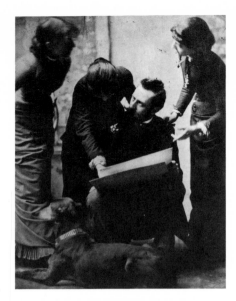

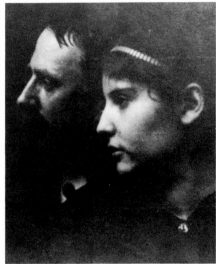

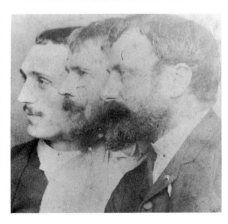

(Top) William Merritt Chase seated with Alice Gerson Chase looking over his shoulder and two unidentified women, c. 1881. (Middle) Mr. and Mrs. William Merritt Chase, c. 1886. (Bottom) Fellow artists, William J. Baer, Robert F. Blum, and Chase, c. 1886.

vaney filled Chase's head with the artistic wonders of the galleries of Europe and with the vital approach to painting practiced at the Royal Academy in Munich, where he had been a student of Alexander von Wagner and Karl von Piloty. The progressive approach and free atmosphere described by Mulvaney excited Chase's interest, but neither Chase nor his family could finance such a European trip, so the idea had to be set aside. But in 1872, this dream became a reality when several prominent St. Louis businessmen provided the necessary funds. These men—Samuel A. Coale, Captain W. R. Hodges, Samuel Dodd, and Charles Parsons—raised the sum of $2,100 for this venture. In return, Chase was to act as their agent, buying European paintings for them. He was also obligated to provide each sponsor with one of his own works painted abroad. In response to this proposal, Chase reputedly exclaimed, "My God, I'd rather go to Europe than to heaven." [37]

WHEN LATER ASKED WHY he had chosen to study in Munich rather than in Paris, Chase answered: "I went to Munich instead of Paris because I could saw wood in Munich instead of frittering in the Latin merry-go-round" [42, p. 30]—an impression evidently conveyed by Mulvaney. In Munich, Chase soon gained recognition both for his technical skill and for his iconoclasm. He worked under Mulvaney's professors, von Wagner and von Piloty, and the latter took a fatherly interest in Chase's artistic development. Von Piloty's attitude toward Chase was likely prompted by his awareness of the young artist's obvious talent and overwhelming vitality. It was not long before his faith in Chase's ability was shared by others.

About 1874, Chase sent his painting *The Dowager* back to W. R. Hodges in St. Louis in partial fulfillment of his obligation. The following year Hodges sent the painting to New York to be included in the National Academy of Design exhibition of 1875, where it was promptly purchased by the noted American artist Eastman Johnson. This honor was followed by critical acclaim for Chase's painting *Keying Up—The Court Jester*, exhibited at the Philadelphia Centennial Exhibition of 1876. And in 1877, to Chase's great satisfaction, his painting *Ready for the Ride* was purchased by the prominent American art collector Samuel P. Avery, who later donated it to the Union League Club in New York. Undoubtedly the greatest tribute of this period was the commission Chase received from von Piloty to paint portraits of the German artist's children.

Chase established many important and lasting friendships during his Munich years (1872–1878). Among his closest associates there were the American artists Frank Duveneck and Walter Shirlaw; the three Americans were referred to as "Father, Son, and Holy

Ghost" by the other Munich students. Before returning to New York in 1878, Chase and Duveneck, in company with another American student, John H. Twachtman, traveled to Venice for a few months. Despite an offer at this time to teach at the Munich Royal Academy, Chase chose to return home, a decision he later explained thus: "I was young; American art was young; I had faith in it." [5] And justifiably so, for his reputation had preceded him through the success of the paintings he had been sending back for exhibitions, and his personal notoriety soon followed.

He arrived in New York with great self-initiated fanfare, determined to establish himself as an artist of the first rank. He became an instructor at the newly established Art Students League of New York and began a distinguished teaching career, a career that would change the course of American art. To gain recognition as an artist, he secured first a small studio in the venerable Tenth Street Studio Building and then the large gallery originally intended as exhibition space for all the artists in the building. Sometime earlier, before it was turned into a studio by Albert Bierstadt, who needed the ample space for composing his monumental landscape paintings, this gallery had fallen into disuse. When Bierstadt gave up the studio, Chase somehow managed to ignore the hierarchy of established American artists by taking over this, the most desirable studio space in New York.[4] This auspicious beginning did not go unnoticed. Charles Henry Miller, an artist who had recently been elected a member of the National Academy of Design, and somewhat of a renegade himself, noted: ". . . he virtually took the town by storm, capturing its chief artistic citadel, and the exhibition gallery of the Tenth Street Studio building became the sanctum sanctorum of the artistic fraternity." [42, p. 56]

Chase's Tenth Street Studio soon became a celebrated salon, frequented by the leading avant-garde art figures of the day. During his student days in Europe, Chase had become an inveterate collector of bric-a-brac of all kinds. He was equally attracted to the beauty of brass pots, Turkish carpets, Oriental carvings, decorative screens, brocade wall hangings, and stuffed birds, all of which were artistically displayed in his studio.

Serving as majordomo was Chase's black manservant, Daniel, dressed in an Eastern robe and sporting a red fez. It was "altogether a nook rich in attractions which carry the fancy back to other climes and the romance of bygone ages." [8, p. 72] The exotic nature of this studio was undoubtedly planned to satisfy Chase's own artistic temperament. Equally important, however, was the attention it generated, thereby attracting both pupils and portrait commissions. The

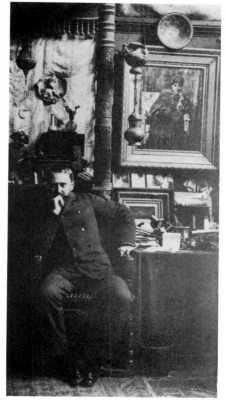

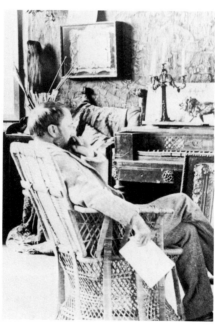

(Top) The artist assuming the pose of his wife in his famous pastel Meditation which is seen on the wall directly behind him, c. 1890. (Bottom) Chase in the Shinnecock Studio, c. 1893.

undisputed high point of the Tenth Street Studio years (1878–1895) was the evening in 1890 it served as the setting for the dance performance of Carmencita, "The Pearl of Seville." The arrangements were made by Chase's friend John Singer Sargent, who had been working on a portrait of this Latin beauty. Mrs. Jack Gardiner, Sargent's Boston patroness and the guest of honor, was surrounded by New York's fashionable elite. The performance, a great success, attracted considerable attention and inspired Chase's own portrait of the spirited Spanish dancer.

Although relatively short, Chase gave the impression of being a "large" man, and was remembered as such by his friends and pupils. This impression was likely conveyed (and certainly intended) by the artist through his dignified manner and formidable personality; it was aided by his use of a top hat, which he soon adopted as part of his standard artistic garb. Elegant and debonair, he generally wore a cutaway coat, a scarf threaded through a bejeweled ring, and a carnation in his buttonhole. He also owned, and showed off with great aplomb, several Russian hounds, including one he named "Fly."

His exotic studio served as a perfect setting for this image, but the whole world was his stage. He was a natural performer and a great showman, as great a self-promoter as he was an artist. His creative energy was unlimited, and his vital personality unbounded. He was articulate on art and art politics. And his dashing painting demonstrations, in which he would complete a major composition within a few short hours, were legendary. These charismatic traits alone would have assured him a strong and devoted following of students. He was, in fact, revered by them. Georgia O'Keeffe, one of his pupils at the Art Students League in New York, recalled: "When he entered the building a rustle seemed to flow from the ground floor to the top that 'Chase had arrived'."[5] Another pupil, F. Usher De Voll, described the rousing inspiration of his mere presence: "There was an all-pervading quiet and seriousness as the students worked on in watchful waiting of the master's arrival. A brisk step—the door flew open—and there entered the dignified, forceful but cheery personality of William M. Chase, a personality in the presence of which we at once felt inspiring influence—the influence of an energetically purposeful life . . . a notable example of 'Art is the expression of man's joy in his work'."[6]

Chase was a rare example of a great artist who was also a great art teacher. His teaching career extended over a period of thirty-eight years (from the time of his return to the United States until his death in 1916) and spanned two continents. Aside from teaching at the Art Students League in New York (1878–1895, 1907–1911), he taught at the Pennsylvania Academy

of the Fine Arts (1896–1909) and at the Chase School (later renamed the New York School of Art, 1896–1907). In addition, he briefly held positions at the Brooklyn Art School and the Art Institute of Chicago. He also held summer classes at Shinnecock Hills, Long Island (1891–1902), and at Carmel-by-the-Sea, California (1914); and with the exception of one year (1906), he conducted summer classes in Europe between 1903 and 1913.

As an art teacher, Chase was unrivaled in America for the number of pupils he taught. At the Pennsylvania Academy of the Fine Arts alone, he taught over 800 students. His dynamic approach and overwhelming enthusiasm were contagious, and his generosity and kindness to his pupils a legend. The roll call of his pupils includes many stellar artists of the succeeding generation and embraces both artists who would continue in his style of painting (such as Irving Wiles and Charles Hawthorne) and those who would find new directions (such as Georgia O'Keeffe, Charles Sheeler, and Joseph Stella). Traditionalists and modernists alike have testified to the positive and significant influence of their early training under Chase, who suppported and encouraged individual expression. In 1913, many of these former students participated in the now-famous Armory Show. In a poignant aside, Jerome Myers, one of the organizers of this show, described Chase's visit to the exhibition: "More interesting to me than all this mob, the millionaires and the celebrities and all the grade B people, was the figure of William M. Chase, with his immaculate high hat and Sargentesque appearance—an artist whose work was not included in the exhibition and who had every reason to feel the indignity of being slighted."[7]

OF ALL CHASE'S TEACHING experiences, his years at the Shinnecock Summer Art School (1891–1902) were probably the most satisfying, and in some ways the most important. The school began as an idea proposed by Mrs. William Hoyt, a summer resident in Southampton, a fashionable resort on the South Fork of Long Island. Mrs. Hoyt had traveled extensively in Europe, where she had been introduced to the methods of the pleinairists (artists who believed in painting directly from nature in the open air). In 1890 she invited Chase to Southampton to discuss the idea of establishing a summer art school based on these principles. By this point, Chase had already aligned himself with the aims of these artists by painting open-air studies of parks in and around Manhattan and Brooklyn. Mrs. Hoyt likely realized that Chase's dynamic personality and his enthusiastic following of devoted pupils would assure the success of this venture. The land and financial backing were provided by

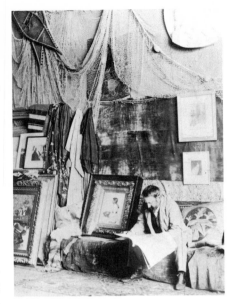

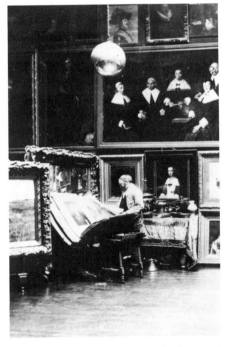

(Top) William Merritt Chase in the Shinnecock Studio, c. 1895. (Bottom) The artist in the Tenth Street studio, with Shinnecock Landscape *on display easel.*

Mrs. Hoyt and two other prominent Southampton residents, Mrs. Henry Kirke Porter and Samuel L. Parrish. The following summer (1891), the school opened. In 1892 a summer house was completed for Chase by the architect Stanford White, a personal friend. This residence made it possible for his family to join him for the summer months while he taught his classes. Many delightful and productive summers followed, as Chase was able to divide his time among his three favorite roles: artist, teacher, and family man.

The school was, as expected, a great success and attracted students from all parts of the country. They were brimming with enthusiasm and could not paint enough canvases to satisfy their zeal. The week at Shinnecock began with a formal criticism by Chase on Monday, which was held at the school studio. Each student submitted his best work of the past week, and up to 200 sketches were often subjected to Chase's witty criticisms in a single morning. These weekly critiques, which were open to the general public, became part of the regular summer ritual. One student reported: "This was as good as a bull-fight to the cottagers and the loungers from the hotels—the patrons were out in full force to partronize and gave parties at little expense and with great gusto to their friends, inviting all they cared to invite to attend the morning criticisms. Carriages and even motors were at the door, the 'nobility' were there, lorgnettes ready, the students all sitting on little camp-stools before a large revolving easel. While Chase criticized the studies on one side, a servant filled the other with more—thus it went round and round until hundreds of daubs had met their fate." [2, p. 392]

The remainder of that day and all of the following were spent painting in the open air, with Chase supervising and offering advice. It was during these sessions that Chase made many of his witty remarks so faithfully recorded by his pupils: "Too much chic, Miss W., it is very dangerous however charming. 'Chic' never yet made up for poor work."[8] Or, more encouragingly: "You dipped your brush in the real thing when you did that tin plate."[9] The rest of the week the students would try to apply Chase's principles to their work. The season was also highlighted by Chase's demonstrations in landscape, still life, and portraiture, which were scheduled regularly but followed no set pattern. The demonstration pieces were often awarded to students as prizes for the best work of the week. Chase also opened his own studio to the public at times and once a month delivered a talk on art, announced in the *Southampton Press* and always well attended.[10]

THE YEAR 1896 WAS pivotal for Chase, especially with regard to his teaching career. In January of that year,

he dismantled his celebrated Tenth Street Studio and sold its contents at auction (including many of his own paintings). The auction, although it attracted considerable attention, proved a dismal failure. Despite generous preliminary publicity in the daily press, the three-day sale grossed under $21,000. The largest sum paid for any of the artist's own work was a mere $610. Even more insulting was the fact that his studio props drew more interest than his paintings. One critic described the sale as "... a sad affair, that made one heartily ashamed of our so-called patrons of American art, who, by their lack of appreciation of the productions of one of the best painters on the continent, make such a result possible."[11] And in comparing this shabby treatment with the considerable respect afforded artists abroad, he continued: "Is it surprising that he [Chase] has resolved to shake from his feet the dust of his ungrateful country, and join the distinguished contingent of the expatriated across the Atlantic?"[12]

This unfounded report of Chase's plans to become an expatriate was likely based on a statement of Chase that was reported in the New York World (later reprinted, in part, in Art Amateur of April 1896). In this article, entitled "The Reward of Art," Chase reflected on the injustice of the recent sale: "The financial prizes in it [art] are very few and extremely uncertain. Much of the very best work that is done is never appreciated and receives no acknowledgement." [11] The disheartened but ever-positive Chase then went on to announce his intention of establishing an American school of art in Spain. Rumors circulated that he would give up his teaching positions in America; but it is unlikely that Chase ever intended to stay in Spain for more than a few months. He returned to teach his summer class at Shinnecock Hills. And, although he did resign his posts at the Art Students League and the Brooklyn Art School in the fall of 1896, he did so not to return to Spain, but to open his own school in New York—the Chase School. He also accepted an important teaching post at the Pennsylvania Academy of the Fine Arts in Philadelphia.

The Chase School was expected to give the Art Students League stiff competition—and it did. Chase had a devoted following of students at both the League and the Brooklyn Art School, and many of them left their former classes to study at Chase's new school. Aside from Chase's personal drawing power, the more liberal policy of the Chase School, modeled after the Académie Julian in Paris, also attracted students. "At the Chase School pupils are immediately put to work on life. . . . There is nothing more interesting for a student than working from life, and nothing so good for training the eye as working from the nude." [20, p. 310] This procedure was very inviting to the many

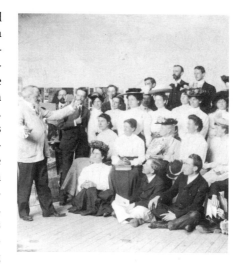

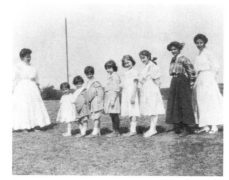

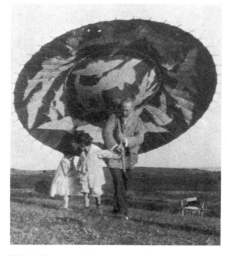

(Top) Chase with his summer class in Madrid, 1905. (Middle) Mrs. Chase and her eight children (left to right): Mary Content, Roland Dana, Robert, Hazel Neamaug, Helen Velasquez, Dorothy Bremond, Koto Robertine, Alice Dieudonnee at Shinnecock, 1908. (Bottom) The artist with his children, Roland Dana and Mary Content, Shinnecock, c. 1908.

former students of the League who had been frustrated in their attempts to get beyond the extended preliminary stage of drawing required there. Although the Chase School was well attended, the artist's lack of business acumen forced him to turn over its management to others in 1898. Chase did, however, remain as the school's chief instructor through 1907, when he returned to teaching at the Art Students League. [41]

CHASE'S SUCCESSFUL AND influential career as an art teacher has at times overshadowed his major status as an artist. In his day, he was considered one of our country's leading artists—a reputation he is finally regaining. An energetic, active man, he participated in most of the leading art organizations of his day and contributed works of art to major exhibitions both here and abroad. After he returned from Munich in 1878, he became one of the founding members of the Society of American Artists, an organization designed to serve those artists who objected to the conservative attitude of the National Academy of Design in New York. In 1880 he was elected president of the Society (serving for one year) and in 1885 was re-elected to this post (serving for ten more years). Eventually the National Academy and the Society of American Artists resolved many of their differences, and in 1890 Chase was elected a National Academician. Although remarkably successful as an Academician, he was still considered somewhat anarchical and "dangerous" by some members of the Academy, and he often used his new role to lobby for the inclusion of fellow artists not yet recognized by this institution. In 1893, after Chase's friend Robert Blum was finally elected to membership but the Boston Impressionists Frank Benson and Edmund Tarbell were rejected, Chase reputedly rushed out of an Academy dinner muttering, "Dry rot!" and "Condemned outrage!"[13]

Chase also belonged to a number of smaller art groups and clubs. He was a member of the Tile Club in New York, an artist's "social sketch" club whose members included Winslow Homer, Edwin Austin Abbey, Elihu Vedder, and J. Alden Weir. These artists met regularly, at one or another of their studios, for leisurely evenings of artistic banter and the painting of small decorative tiles. They also made several summer excursions into the countryside and illustrated these jaunts for Scribner's Monthly and Century Magazine. Chase became a member of this group by 1879 and was dubbed "Briareus" because of his prolific nature. He participated in several of the club's summer excursions, including a trip to eastern Long Island in 1881, at which time he painted A Subtle Device. In this clever work, he depicts himself as a gentleman artist, protected from persistent mosquitos by a contrivance of

netting. Aside from being an interesting self-portrait, this painting signals Chase's new direction in landscape painting. Prior to these summer excursions, Chase had painted very few landscapes; but by the mid-1880s this genre became a major form of expression for him. In fact, this period was in many ways an important transition in Chase's artistic development.

Between 1881 and 1885, Chase made yearly trips back to Europe, where he spent summer months in Paris (1881, 1882), Spain (1881–1883), and Holland (1882, 1884, 1885). It was at this time he became acquainted with the work of the pleinairists and began painting a number of his own landscapes in the open air. Many of these were painted in the company of his friend Robert Blum, at Blum's residence in Holland during the summer of 1884. Two years earlier they had discussed the idea of forming a society of pastelists, an idea that was realized in 1884 when they held their first exhibition (along with thirteen other American artists) under the title of the Society of Painters in Pastel. Several exhibitions of this loosely knit group followed in subsequent years.

As a result of Chase's exposure to the work of the pleinairists and his own experimentation with the pastel medium, his palette became lighter and brighter and the number of his landscapes increased markedly. After returning from Holland, he began painting outdoor scenes in and around New York, including its parks, harbors, and seaside. The subtle tonalities of these works, painted between 1885 and 1890, are to some extent indebted to the style of James Abbott McNeill Whistler. Chase was a great admirer of Whistler's work, and in 1885 they spent the summer together in London, during which time they painted each other's portraits. Unfortunately, Whistler's portrait of Chase was never completed, or has since been lost or destroyed. Chase's portrayal of Whistler was completed, however, and created quite a scandal when exhibited in the United States. The critics described it as a caricature, a lampoon. And although both Chase and Whistler benefited from the publicity it stimulated, Whistler never forgave Chase for what he considered a "vicious deed." Chase, instead, thought of this dashing portrait of his artistic colleague in different terms, as a pictorial form of repartee. [15]

In 1880, Chase was introduced to Alice Gerson, who agreed to serve as his model and, later (after six years of courtship), consented to be his wife. The announcement of their marriage came as a bit of surprise to the press and Chase's fellow artists, who considered him "a bachelor of the most confirmed type." That same year, 1886, Chase was offered his first one-man show, which was held at the Boston Art Club in November-December. This was a comprehensive exhibition of

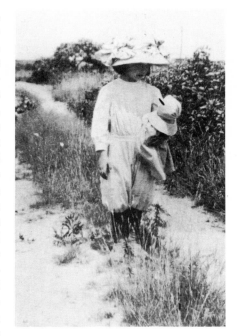

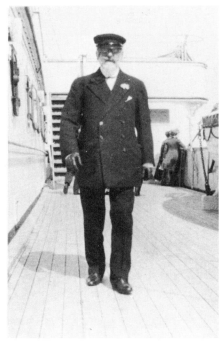

(Top) Mary Content on the old sand road, Shinnecock, 1910. (Bottom) William Merritt Chase aboard the Lusitania, c. 1911.

133 works (including 25 pastels). The show attracted much attention and was favorably reviewed: "It was the largest exhibition that Mr. Chase ever made, we think, and it rewarded the artist in the completest and most satisfactory manner. The versatility of the painter, his admirable technique, his mastery of materials and his powerful color perceptions were the astonishment as well as the delight of all who saw these pictures." [4] The exhibition was, in retrospect, a chronicle of both his Munich style (a combination of bravura brushwork and Old Master glow) and his transitional work of the 1880's, which was lighter and more atmospheric.

By the end of the decade (1889), Chase was already noted for his versatile technique and wide range of subject matter. As Kenyon Cox observed: "Of all our artists, Mr. Chase is the most distinctly and emphatically a 'painter' . . . place him before a palace or a market stall, in Haarlem, Holland, or Harlem, New York, and he will show us that light is everywhere, and that nature is always interesting." [21, p. 549] By this time, Chase's repertoire included landscapes, still lifes, portraits, figure studies, and interiors.

Between 1891 and 1902, Chase was preoccupied with his summer school at Shinnecock Hills, Long Island. His own landscapes of this period are bright, fresh, full of sunshine and sea air; they are crisp and clear, more colorful than the park scenes of the 1880's. His protraits and figure studies of this period display his successful synthesis of the best of European style and technique (both past and present) and the strong, direct, and unsentimental expression of his own native artistic heritage. What comes across in all his work—whether portrait, still life, or landscape—is his own sureness, his great self-confidence as expressed through his bold, vital approach to painting. Every stroke of the brush has meaning, direction, and purpose. There are few, if any, changes in the compositions of this period. He was at the high point of his career; he knew it—and his art reflected this self-awareness.

As the 19th century came to a close, Chase could look back at his career and his life with great satisfaction and pride, a life as complete as any man could hope for. He had a loving wife, a healthy brood of children, a larger progeny of art students, and the admiration of the general public. And if he was occasionally beset with financial problems (mainly self-inflicted by his intemperate buying sprees), he bravely sold his collection of bric-a-brac and carried on. When he had the chance, he would simply buy it all back—and more. But he did not look back; he always looked forward to some new project, a new painting, or experiments with a new technique. There was always a new chal-

lenge. When asked in 1910 (the year of a major retrospective of his work held at the National Arts Club in New York) which painting he considered his masterpiece, he pointed to a blank canvas: "It is that one. Yes, that is my best work. I have painted on it thousands of times, and I am getting on with my art because each year I paint a better picture there." [14, p. 445] He was at that time sixty-one years old.

In 1902, the last year he would conduct classes at Shinnecock, he went to London to have his portrait painted by his friend John Singer Sargent. The portrait, commissioned by his students as a tribute to their beloved master, was to be donated to the Metropolitan Museum of Art. By this time, he had been teaching and painting for twenty-four years since his return from Munich; but he saw no reason to stop, or even slow down, his activity. His work had been honored with numerous awards and medals, both at home and abroad. An especially meaningful honor came in 1908 when Chase was commissioned to paint a self-portrait for the Uffizi Gallery in Florence; he was one of the few Americans to be acknowledged in this way. And in 1913, his painting *Dorothy and Her Sister* was purchased by the Musée du Luxembourg, described as "that anteroom of immortality in Paris where the masterpieces of the living are kept, some to be transferred to the Louvre ten years after their painters have died."[14] Unfortunately this test of time could not be applied to Chase's work. Because of the outbreak of World War I, the painting was never shipped, and the French sale was never consummated.

IN THE LAST DECADE of his life, Chase became especially attracted to Italy, with its strong light and clear skies. In 1907 he purchased a villa in the hills of Fiesole, just outside Florence, which he visited regularly between 1907 and 1913 (except for the year 1912, when he conducted a summer class in Bruges). During this period his palette changed again: his color became stronger under the influence of the brilliant sunlight of Italy. In 1914, Chase traveled to California to hold what would be his last summer art class at Carmel-by-the-Sea.

While in California, he resumed making monotypes, a medium he had first used as early as 1882.[15] Always experimenting, he produced these late monotypes by inserting the wet plate and paper in the wringer of a washing machine and using the pressure to print his image. Chase's work in this medium is very rare. Essentially a colorist, he had little interest in monochromatic images (as these prints were).[16] He told his students: "I don't believe in black and white. Much use of it chills the color sense. I don't allow my children to use it. They do all their drawing in color. . . . On the other hand, I like to make monotypes—so there you are!" [29, p. 434]

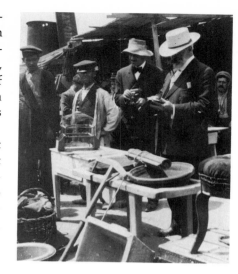

(Top) The artist bartering for collectibles, Italy, c. 1911. (Bottom) Chase in the garden of the Florentine villa, c. 1911.

This dichotomy can be explained by Chase's extreme interest in the effects of light. In Chase's monotypes, all is reduced to light and shadow, an exercise and a challenge for this master of technique. In this medium he created mostly portraits and figure studies; the comparatively few landscapes are so free they look almost like complete abstractions. Without a doubt, his major work in this medium is *Reverie* (c. 1895), a portrait of his young wife—certainly one of the finest American monotypes of all time.

During the closing decade of Chase's life, he gained great renown for his still lifes of fish. Duncan Phillips wrote that he was "unequaled by any other painter in the representation of the shiny, slippery, fishiness of fish." [40, p. 49] Chase himself thought that perhaps in the end he would be primarily remembered as a painter of fish. At this time his fish still lifes were eagerly sought after by all the major museums in the country. In retrospect, there is no question that these works represent a high point in the development of Chase's technique. Some may dislike the subject matter, but no one can fault his technical skill in capturing the slick, irridescent quality of fish. After all, Chase considered any subject worthy of painting as, he frankly professed: ". . . it is never the subject of a picture which makes it great, it is the brush treatment, the color, the form. There is no great art without a great technique back of it." [31] And Chase was an undisputed master of technique.

IN 1915, CHASE RETURNED to California once again, this time to serve on the Art Committee of the Panama Pacific International Exposition in San Francisco. He was also there to supervise the decoration and arrangement of a gallery in the Art Building of the Exposition devoted exclusively to his work. This fitting tribute to the revered sixty-six-year-old artist would be the last major exhibit of his work before his death the following year. After several months of lingering illness, he died on October 25, 1916, one week shy of his sixty-seventh birthday.

The events surrounding his death and funeral are somewhat obscure, considering his celebrity. He had left for Atlantic City in September, to rest and regain his health. Before his departure, his faithful pupil Annie T. Lang stopped by his studio to bid good-bye. In a letter to a classmate, she later recalled the sad fate of this once vital and spirited man: "He was pitifully frail and *little*—I never saw him so small and delicate. Waveringly he gathered a few sketching materials together and I helped him tie the bundle. 'Shall you try to paint?' I asked. 'Yes,' he said, 'perhaps I can forget this pain if I work—probably on the beach I shall see many charming notes—there is nothing like painting, Annie!'"[17] She continued: "I insisted on carrying his

package which was really heavy. He protested in his usual gallant manner. . . . At 16th Street and Irving Place he stopped and said that I must not go further. . . . So I bid Mr. Chase 'au revoir' there on the corner. He took his package and walked away. . . . I looked back at him and I saw that his hat had blown off. It rolled rapidly for almost a block. He looked so frail—I shall never forget how he looked then, with his bare head and careful slow step!"[18]

That was the last she would see of Chase. In the same letter she described his final days, during which she kept a vigil outside his home: "Friends called up almost daily. We were invariably told that he was getting on well and would teach this winter, etc. I was apprehensive, but could get no real knowledge. I sent him flowers. Suddenly the papers pictured him and said he was dangerously ill. . . . It was like a bolt from a blue sky! I immediately called at the house. He was unconscious. I was simply distracted! I was on pins and needles from that time on! The next day I called up several times but he was still unconscious. The day after that I could not be still. I could not do anything! Telephoning was unsatisfactory, I went to Stuyvesant Park—just in front of the Chase house. I could see his windows and a nurse moving about. I sat there for hours. It rained a little and was chill and grey. About 5:45 o'clock I got up all cramped and cold and came here to the club [National Arts Club]. I ate a little bit. Then I went back. I was struck to see that his windows were all dark and the shades down tight. On the floor below was a blaze of light! I sort of knew! I went to a drugstore and called up on the phone. Mrs. Chase's sister answered and told me that Mrs. Chase had instructed her to tell me that Mr. Chase had died at 5:15 o'clock!"[19] The private funeral was two days later.

WILLIAM MERRITT CHASE was a significant, colorful member of the American art fraternity at the end of

(Top) William Merritt Chase feeding pigeons in the Piazza San Marco, Venice, 1913. (Bottom) The artist and his wife, c. 1913.

the nineteenth century. His fame and his influence as both an artist and a teacher were internationally acknowledged. He was a master technician; but more important, he was a brilliant artist who set out to establish a distinctive American art statement. That he succeeded is but one measure of his genius. That his work lives on today, with its spirit and power intact, is final proof—if proof were needed—of its enduring value and of his stature as one of our most eminent American artists. The many eulogies that followed his unexpected death remain as testimonies to his great contribution to American art as well as his contagious enthusiasm and vital spirit.

A writer for *The American Art Student*, Frank Alvah Parsons, in noting the death of William Merritt Chase, wrote: "Perhaps the greatest thing to mark the life of this otherwise great man was the fact that out of an accumulation of almost unthinkable, inartistic appreciation in this country, William M. Chase espoused the cause of art, and worked at first almost alone for its propagation and maturity." [38] F. Usher De Voll, one of Chase's students, wrote: "Mr. Chase has accomplished a wonderful work for the good of art, both nationally and internationally. His honest straightforward vigorous American spirit is truly reflected in the sincerity of his art, and what a great legacy he has left the art world, not only in the masterpieces from his brush, but the wholesome influence of long years of heartfelt devotion to his students—Ah! the living inspiration he has left. America may well be proud of this great man. America is!"[20]

The life of William Merritt Chase is immortalized best in his work. His genius is reflected in the brilliance of his technique. His soul rests in the spirit with which he imbued his work. His many paintings, drawings, and prints are a lasting celebration of American art.

Color Plates

". . . the aim of every great artist, so far as technique goes, is, to as great an extent as possible to do away with the intermission between his head and his hand. . . ." [17, p. 50]

The Munich School of the 1870's was noted for the emphasis it placed on bravura brushwork. Aside from being a daring display of technique and a brilliant performance, this approach to painting allowed for greater freedom of expression. However, the clever brushwork and rapid application of paint were not ends in themselves (as so often stated by contemporary critics) but were rather a means of quickly rendering transitory subject matter. Indeed, these freely sketched studies have an immediacy about them, a directness and spontaneity, lacking in the work of those artists who adhered to the more academic methods of the time. The "unfinished" quality of these paintings was especially frowned upon by the conservative National Academy of Design in New York. The Society of American Artists (formed in 1878), however, had a more progressive attitude and welcomed such work.

In a review of the Society of American Artists' inaugural exhibition, in which Chase's painting *The Apprentice* appeared, a sympathetic critic explained the approach of these artists: ". . . they try at the start to get the benefit of the first, fresh impression of their subject, whatever it may be, and treat all subsequent work as secondary thereto. If, at the end of the first hour, the painter feels that further work will not better the picture, he stops short."[21]

The Apprentice is one of a series of paintings by Chase, Duveneck, and J. Frank Currier treating a similar theme (a youth smoking, whistling, etc.), as a means of experimenting with and developing this bravura brushwork. Duveneck painted a version of this theme as early as 1872 *(The Whistling Boy;* Cincinnati Art Museum), and Currier executed a similar work with the same title (Indianapolis Museum of Art) about 1873. The first of Chase's paintings in this series, *Impudence* (Addison Gallery of American Art, Andover, Mass.), has also been dated about 1873.

The Apprentice, dated 1875, is one of at least three works painted by Chase between 1875 and 1876 in which he used the same model.[22] This model also posed for Duveneck three years later (1878), appearing in his painting *He Lives by His Wits* (Private Collection), which is nearly a mirror image of Chase's *The Apprentice.*[23] The distinct interrelationship of these works, both thematic and stylistic, clearly indicates the close association of these three artists.

When *The Apprentice* was first exhibited in this country in 1878, its free, direct style was welcomed as a refreshing surprise by the critic Mariana Griswold Van Rensselaer, who reported: "The handling was broad to excess, and the canvas full of life and 'go'—aggressively so, if I may use such a word to mark the strong contrast between this bit of intense, if unbeautiful reality, and the vapid discretion, the smooth nothingness, the sickly conventionality of the portrait studies to which our public had been most accustomed." [45, p. 95]

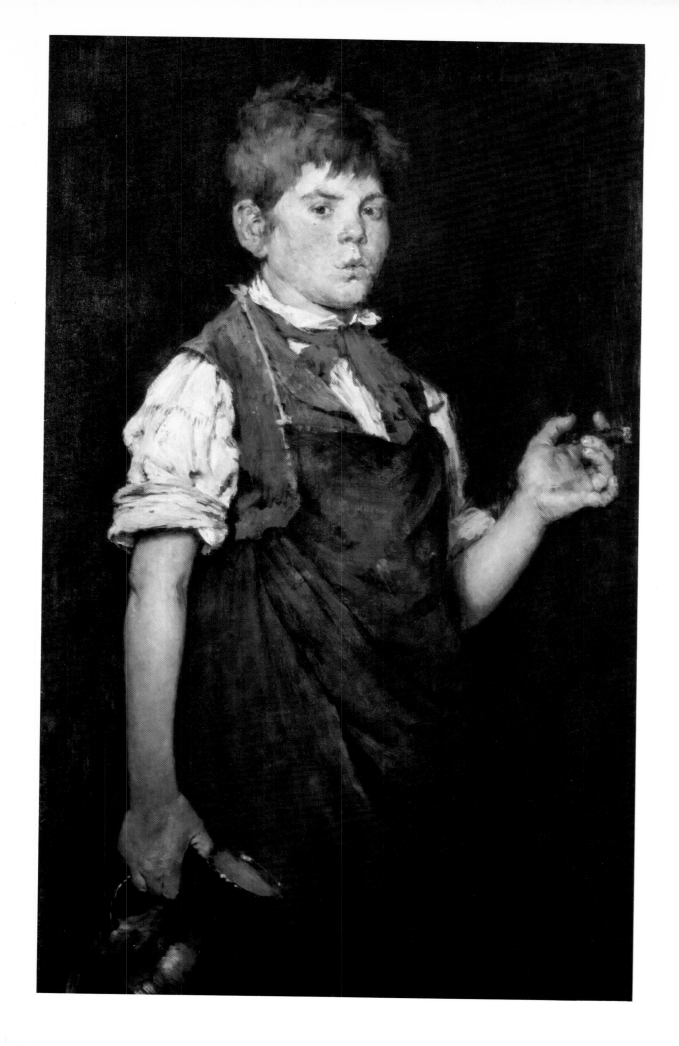

Plate 2
KEYING UP—THE COURT JESTER
Oil on canvas
39 3/4" X 24 7/8" (100.97 cm X 63.18 cm)
Signed
1875
Pennsylvania Academy of the Fine Arts, Philadelphia
(Gift of the Chapellier Gallery)

"Don't hesitate to exaggerate color and light. Don't worry about telling lies. The most tiresome people—and pictures—are the stupidly truthful ones. I really think I prefer a little deviltry."
[29, p. 438]

Chase delighted both his pupils and the general public with his wit and clever brushwork. *Keying Up—The Court Jester,* painted in 1875 while Chase was still in Munich, is a prime example of Chase's own deviltry by means of exaggeration. When this work was exhibited for the first time in this country in 1876 at the Centennial Exhibition in Philadelphia, it was awarded a medal of honor and attracted much critical attention as well. In praising the impressive and powerful nature of the work, the critics were in accord; they disagreed, however, about Chase's use of color. While one praised the artist for his "noble sense of color,"[24] another found the bright red of the jester's costume "overpowering." [46, p. 136] In exaggerating this color, Chase was assured his painting would not be overlooked in this extensive exhibition. And in carrying out this devilish deed, he succeeded in attracting the attention of art critics and in establishing a place for himself as an artist, which would be invaluable to him on returning to America two years later (1878).

Chase's tendency to exaggerate for effect at times also inspired an anecdote relating to this work, which he used to entertain his students. According to Chase's early biographer, Katherine Metcalf Roof, the artist recounted that the model for this work, was "fond of imbibing anything of an alcoholic nature that happened to be available. . . . One day while the painter was out of the room the model consumed a considerable quantity of hair tonic which Chase had put in a whiskey-bottle, with the result that the next day the jester was not present in the studio. [42, p. 41] Although this beguiling story is more likely fiction than fact, it did serve to amuse Chase's pupils as well as to draw more attention to the painting itself.

It is clear that Chase intended *Keying Up—The Court Jester* to be an "exhibition piece," displaying both his technical skill and his wit. He made several preliminary sketches for this painting; this was an unusual procedure for Chase, who generally painted directly without the use of any preparatory work. These sketches indicate both the serious thought that went into composing the final work and the importance attached to this exhibition piece by Chase himself. Chase also made an etching based on this painting, in which the figure is reversed. This etching, which was available to the general public at a very modest price, served to draw further attention to the original painting and was, in a sense, a promotional gambit devised by the artist to publicize the work and extend the interest generated by the initial impact of his painting.

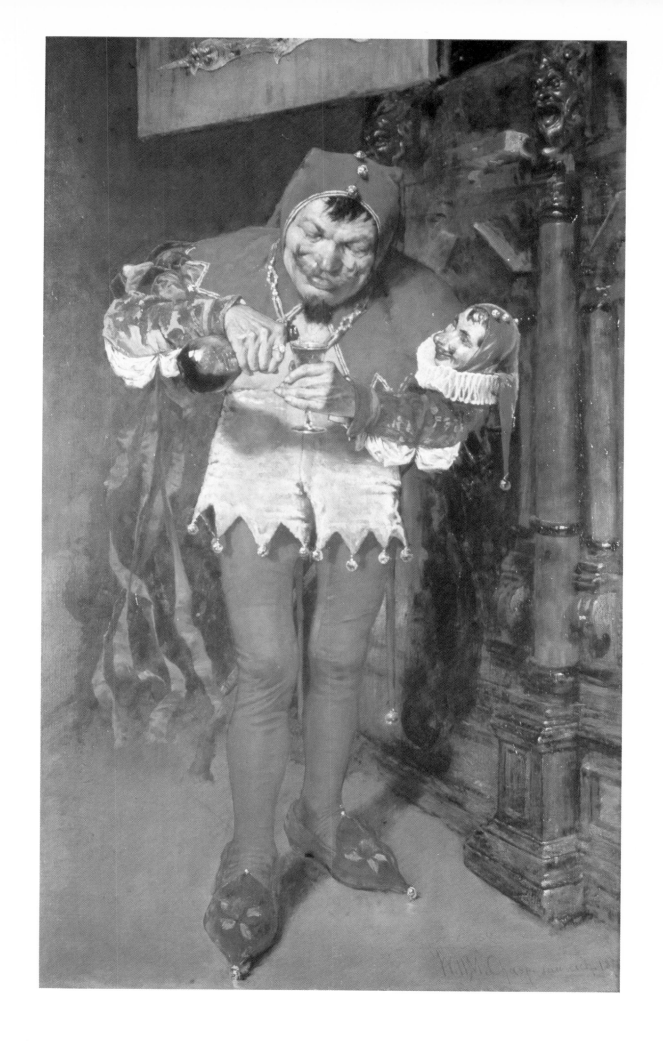

Plate 3
READY FOR THE RIDE
Oil on canvas
54" X 34" (137.16 cm X 86.36 cm)
Signed and inscribed: "Munchen 1877"
1877
Union League Club, New York City

"My God, I'd rather go to Europe than to heaven." [37]

This expansive declaration was made in response to an offer by several St. Louis businessmen to support Chase's art studies abroad. With a "scholarship" of $2,100, Chase left for Munich in 1872 to study art and to act as a buying agent of European art for his providential benefactors. He also agreed to send each man one of his own paintings completed while in Europe. He chose the Royal Academy in Munich rather than any of the popular art schools of Paris, as he explained later: "I went to Munich instead of Paris because I could saw wood in Munich, instead of frittering in the Latin merry-go-round." [42, pp. 30–31] At the Royal Academy, Chase studied under the German artists Alexander von Wagner and Karl von Piloty and was a companion of the American artists Frank Duveneck, Walter Shirlaw, John W. Twachtman, and J. Frank Currier.

Chase was a competent artist with promising talent and ability before he left for Munich, but it was there that he developed his mastery of the painting medium, exemplified in his bravura brushwork as well as his heightened respect for the Old Masters. After several years of study abroad, Chase began sending his work back to the United States for important exhibitions, including those held at the National Academy of Design in New York (1875, 1877, 1878) and the 1876 Centennial Exhibition in Philadelphia. These works were so well received by the critics and the general public that, when he returned home in 1878, his reputation had preceded him. Although he had been offered a teaching position at the Munich Royal Academy, Chase felt compelled to return to his native land and explained his motivation thus: "I was young, American art was young; I had faith in it." [5, p. 1250]

On his return to New York, Chase accepted a teaching position at the newly formed Art Students League. He also became a founding member of the Society of American Artists, a new organization opposed to the conservative attitude and practices of the National Academy of Design; among its purposes was to offer an alternative exhibition space for American artists, especially those recently returned from abroad with new ideas.

Ready for the Ride was one of four paintings exhibited by Chase at the inaugural exhibition of the Society of American Artists held in 1878. (His other contributions were *The Wounded Poacher, The Apprentice,* and *Study.*) It created a sensation and became one of the most talked about paintings of its day. It was described by one critic as "by far the most interesting picture of the year. . . . It is a fascinating canvas, very sympathetically imagined, and full of an undeniable pathos. More than any other of Mr. Chase's pictures, it charms the feelings and excites the imagination." [46, pp. 135–136] Many years later it was still regarded by a critic from *Art Amateur* magazine[25] as one of his finest female portraits; and when it was exhibited in a restrospective exhibition at the National Arts Club in 1910, it was praised as "one of the American accomplishments of all times." [26, p. 51] At the time of Chase's death in 1916, it was hailed as "equal to any portrait ever painted by an American."[26]

Chase's paintings of the 1870's, such as his major work of this period, *Ready for the Ride,* served to establish his reputation as a master technician as well as an American artist of the first rank. In spite of this early celebrity, he continued to develop a more distinctive style of painting. He later instructed his pupils: "Don't dwell over success, any more than failure. Start fresh every day." [29, p. 433] In the early 1880's, under the influence of Alfred Stevens and following his own experiments with pastel, Chase abandoned his dark and brooding Old Master style of painting and turned to a brighter palette, with which he created more colorful and atmospheric works. He retained the vigorous brushwork from his Munich years, which not only was well suited to his more impressionistic style of painting but also served to distinguish his work from that of mere fadists who copied the Impressionists' style without really understanding their principles.

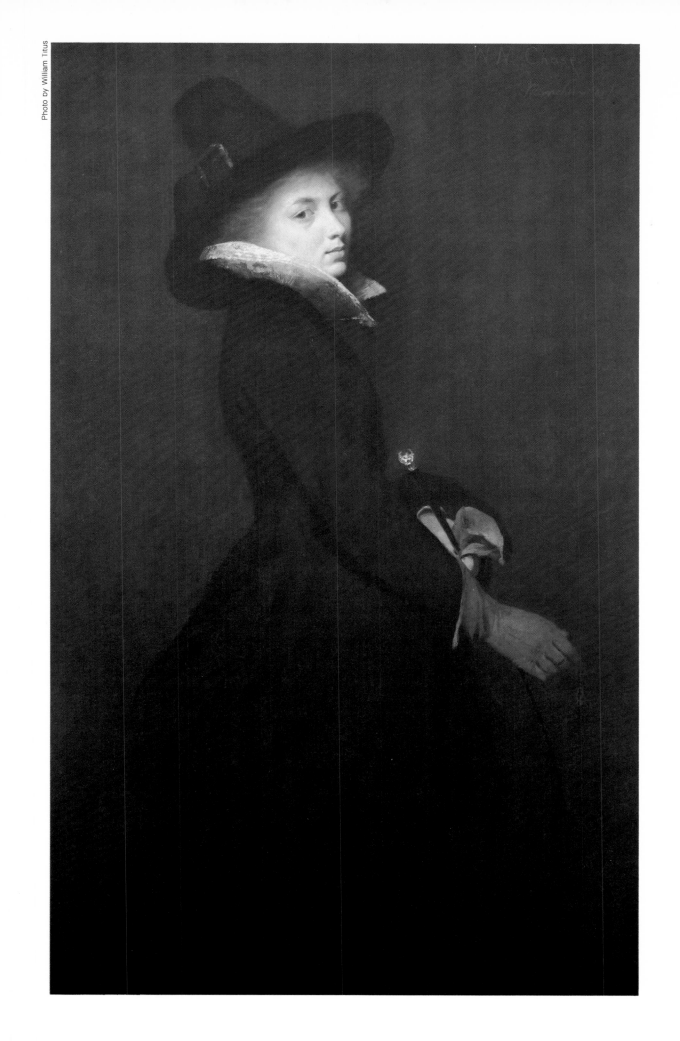

Plate 4
INTERIOR OF THE ARTIST'S STUDIO (THE TENTH STREET STUDIO)
Oil on Canvas
65" X 77" (91.5 cm X 122 cm)
Signed
1880
The St. Louis Art Museum, St. Louis, Missouri
(Bequest of Albert Blair)

"Genius is only recognized in people who succeed." [12]

Chase's early years of struggle were soon overshadowed by the brilliance of his later success—a success, in part, "created" by the artist himself. His first introduction to the New York art world was as a young art student at the age of twenty. He had come from the Midwest with modest means and chose as his first studio a room in the Young Men's Christian Association building downtown. These early years of study, both in New York and later in Munich (1872–1878), were years of privation, later recalled by the artist: "I have known times when I had to live on a bit of bread and cheese and borrow paint from my comrades. I have known that; but I have never lost spirit; never lost hope." [16, p. 115] After completing his studies in Munich, in great spirits, Chase informed his artist friend William S. Macy of his intention to return to the United States. He added audaciously, "I intend to have the finest studio in New York." [42, p. 51]

His goal was soon achieved when, on his return in 1878, he managed to obtain several rooms and the main gallery of the Tenth Street Studio building. This move created quite a stir, as was indeed intended by the clever young artist. Charles Henry Miller, a contemporary artist, described the effect: "Mr. Chase, upon returning to New York, virtually took the town by storm, capturing its chief artistic citadel. . . ." [42, p. 56]

The Tenth Street Studio building had been built by John Taylor Johnson, a prominent American art collector of the day. The large gallery taken over by Chase had originally served as a public exhibition space for the artists in the building. It later fell into disuse and then served as a studio for Albert Bierstadt, who found it well suited for composing his monumental landscape paintings.[27] How Chase, of modest means and just returning from his studies abroad, managed to outdo more likely contenders for this coveted space remains something of a mystery. But, in winning the desirable studio and filling it with fine objects and works of art from all over the world, he managed to create both a sumptuous setting for himself and a much-admired display for the rest of New York. These richly decorated quarters attracted more attention and publicity than any other artist's studio in the country and placed Chase firmly before the public eye.

The studio and its magnificent contents served as testimony to the artist's fine taste, his affluence, and, most important, his conspicuous success. Many aspiring and curious art students were drawn to the classes Chase held at the studio, and the rich and fashionable came to buy paintings and to commission portraits. This canny display of success generated actual success and, in turn, drew attention to Chase's true genius, which he himself had never doubted. He shrewdly realized the value of outward appearance in his native country and had the intelligence, grace, and wit to make it work for him.

One writer gave the following description of a trip to the illustrious artist's studio: "As you enter from the street, at the end of the hallway you will see a door, with a curiously carved bronze knocker. On the door is the painter's name, and the announcement that he is only at home to visitors on Saturdays. Turn to the left, and at the end of another passage you will find a second door, usually ajar. As you push it, an ingenious mechanism sets a musical instrument in motion and next moment you will find yourself face to face with the artist in a dark but sumptuous room filled with treasures gathered together from half the curiosity shops of the old world. From this outer temple you pass through a doorway into a second and larger room, the studio proper. It is lighter and loftier than the first, less cumbered with curios, and contains the artist's most cherished paintings." [27]

Interior of the Artist's Studio (1880) is one of several major paintings of this celebrated studio, painted by the artist in the early 1880's. There is no doubt these paintings were intended to dazzle the public both with the opulence of the studio's contents and with the artist's own dashing style of painting. Because of the importance of the objects (as opposed to the figures) in these studio paintings and their pervading quiet mood, at times they were described as "still life" by contemporary critics. One critic, in fact, referred to this particular painting as Chase's "still-life painting at its best." [46, p. 136] Chase's incidental treatment of the figures in this work was undoubtedly intentional. He portrayed himself in shadow, as if leisurely discussing what appear to be prints with a female caller or model. The scene is consciously meant to focus on the artist's affluence and success, as witnessed by the fine display of art objects in his studio. Almost out of the picture plane, the artist himself joins in appreciating this splendid display created for his own pleasure and for the delight of the true art lover. [19]

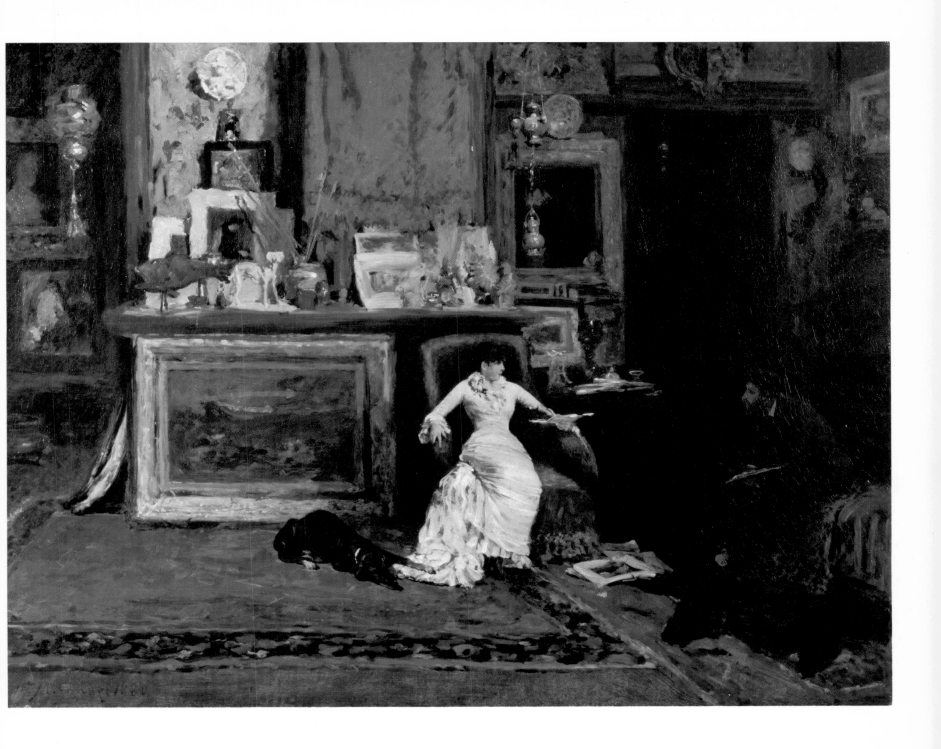

Plate 5
PORTRAIT OF MISS DORA WHEELER
Oil on Canvas
62 1/2" X 65 1/4" (158.75 cm X 165.74 cm)
Signed
1883
Cleveland Museum of Art
(Gift of Mrs. Boudinot Keith in Memory of Mrs. J. H. Wade)

"Do not imagine that I would disregard that thing that lies beneath the mask . . . but be sure that when the outside is rightly seen, the thing that lies under the surface will be found upon your canvas."[28]

Chase's *Miss Dora Wheeler* is the portrait of a strong, even intense, personality—a direct likeness, to be sure, but one with a hint of inscrutability. In sum, there is no sacrifice of character in the work; yet in spite of its popularity and acknowledged brilliance, the painting stirred controversy at the time. The argument was over whether or not Chase willfully ignored the personality of his sitter in favor of displaying his technical skill as a painter. The painting, expressly intended as an "exhibition piece" rather than a commissioned portrait, was first exhibited at the Paris Salon of 1883. From that exhibition it went directly to Munich, where it was featured at the Internationale Kunstaustellung the same year. In Paris it was awarded an honorable mention, and in Munich it won a gold medal. The following year the work returned to the United States, where it appeared for the first time in the annual exhibition of the Society of American Artists.

In a review of the Paris Salon, W.C. Brownell described this painting as "an easy and frank exercise." He continued: "Miss Wheeler counts for next to nothing in it, not only in lack of character . . . but in point of pure pictorial relation to her surrounding."[29] On the other hand, a German critic who praised the work when it was shown in Munich was particularly impressed with Chase's communication of his sitter's personality: ". . . as genuine an American as ever was, handsome moreover, and interesting also, though apparently gifted with more cleverness than feeling. The way in which she fixes her piercing look on you, without herself betraying anything, puts you in mind of a sphinx."[30] Pecht described Chase, himself, as the "gifted (but to our taste much too bizarre) full-blooded American." Although praising the strong character of this painting, he objected to Chase's frank use of the work as a means of demonstrating his artistic prowess. Criticizing the work on these grounds, he described it as "a somewhat disagreeable experiment of contrasting yellow tapestry and yellowish flowers in a flower pot with a blue silk dress, as though herein lay the chief interest."[31] Seeing this masterwork of technique as a clever game presented by the artist to his public, the critic went on to interpret the cat playing with a mouse[32] (seen in the pattern of the wallhanging behind the sitter) as an emblem. However, if Chase used this pictorial element as an emblem, it is more likely that he meant it to represent or amplify the sitter's attitude. Like the cat, represented in the same color as the sitter's gown, Dora Wheeler plays a game with her viewers. She is alluring, captivating, yet somewhat intimidating. Like the Sphinx of Thebes, who proposed a riddle to all passersby and then destroyed those who could not answer correctly, Dora Wheeler is in full control of the situation.

Dora Wheeler (Keith) was born in Jamaica, Long Island, in 1857. At the age of twenty-one (1878), she became one of Chase's first private pupils and studied with him at his celebrated Tenth Street Studio. She later went on to complete her artistic training at the Académie Julian in Paris, before returning to New York in 1883. That year she joined her mother Candace Wheeler in revitalizing the decorative arts firm of Associated Artists,[33] for which she created a number of original figural tapestry designs. She also designed greeting cards for Louis Prang of Boston and painted a series of portraits, including likenesses of such celebrities as Walt Whitman and Mark Twain.

Dora Wheeler was twenty-six when she sat for this remarkable painting, and had just returned from her studies abroad. This painting, portraying the young woman in her own studio,[34] commemorates to some extent her return home as a serious and mature artist. In a broader sense, the painting is another of Chase's representations of the "new breed" of American woman: sincere, intelligent, direct, and strong; able to make serious judgments and decisions, eligible for a career of her own. The decorative elements in this composition, so ably executed yet overpowering to many contemporary critics, are an extension of the sitter's personality and subtly allude to her career in the decorative arts. In actuality, then, they enhance rather than overwhelm Dora Wheeler's own strong character.

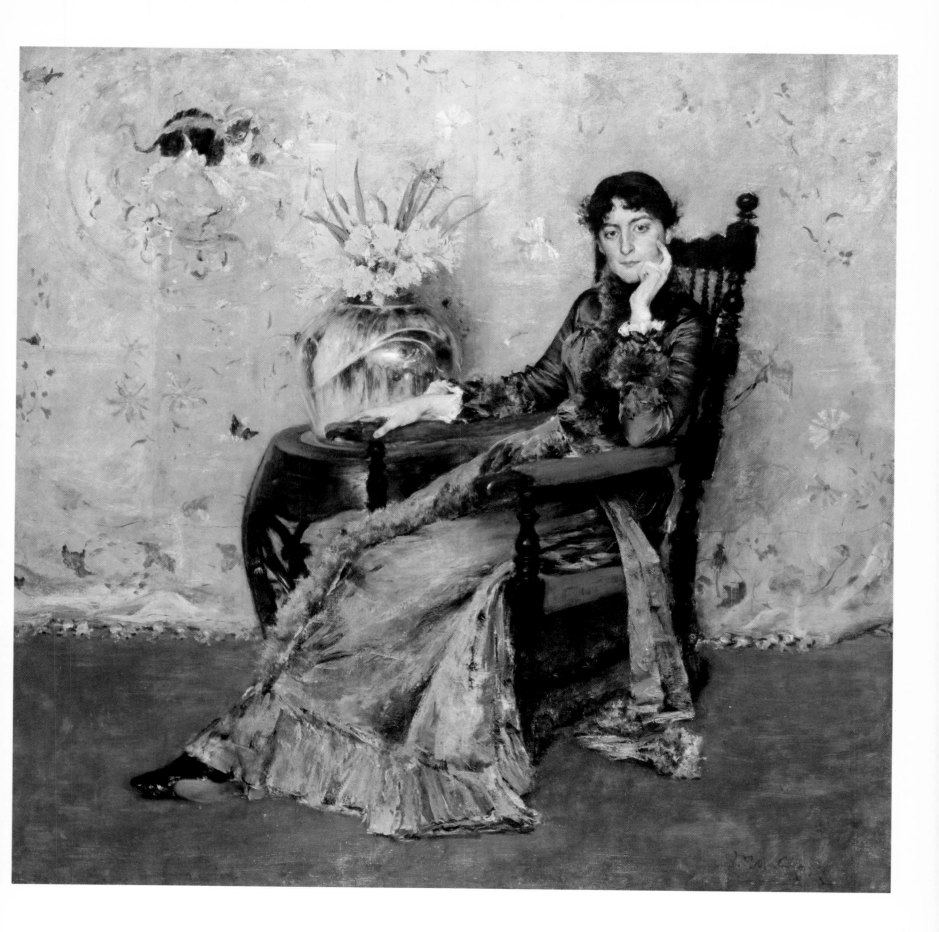

Plate 6
A SUMMER AFTERNOON IN HOLLAND (SUNLIGHT AND SHADOW)
Egg tempera
65 1/2" X 77 3/4" (166.3 cm X 197.5 cm)
Signed
1884
Joslyn Art Museum, Omaha, Nebraska

"I will venture the remark: that no matter what you do, so long as you succeed in what you do, you will be forgiven. . . ." [16, p. 122]

A Summer Afternoon in Holland, long believed to be an oil on canvas, is actually a painting in tempera (in which the white of an egg, rather than oil, is used as the vehicle for pigment). In his usual intrepid way, Chase shocked critics and public alike when he exhibited this large work at the American Watercolor Society exhibition of 1886.[35] One critic, commenting on Chase's audacity, reported: "He acknowledgedly exhibits two water-color canvases of such portentous size that nothing will be more certainly known than that Mr. Chase is around. Moreover, certain highly cultivated writers have imparted to the public through various prints that those paintings partake of the nature of an omelet—that is to say, they are made with eggs: and this impartment of a highly recondite technical secret has whetted the public appetite for Mr. Chase and his works to a condition of unappeasable sharpness."[36] By exhibiting this painting at the American Watercolor Society Exhibition, rather than at one of the other annual exhibitions that included works in various media, Chase cleverly managed to draw a great deal of attention to his work.

One can only imagine the monumental impact of this work when compared to the many small watercolors surrounding it in the exhibition. The sophisticated art critic Mariana Griswold Van Rensselaer noted: ". . . it was so painted, finally, as to look more like an unvarnished oil than like an aquarelle . . . [it] killed everything about it . . . nothing could have been more solid, yet nothing fresher. . . ." Describing the general public's reaction, she found that "to many eyes, it had neither virtue nor value." But, she added, "These were the eyes of that 'general public' from which one hardly expects to get recognition for anything new and unexpected—for anything true and good, if its truth is unconventional and its excellence is not 'pretty.' Those who are better able to see and better entitled to speak—the artists and the critics—these . . . were unanimous in their praise of the remarkable technical qualities of the picture."[37] Chase's brazen act was forgiven by critics and artists because he succeeded in impressing them

with his fine technical skill in utilizing a medium not generally employed by artists in this country at the time.

A Summer Afternoon in Holland must be considered one of Chase's finest works, certainly a tour de force of egg tempera painting by an American artist. Aside from the technical interest of the medium employed in this work, the subject and setting of the painting are extremely engaging. The seated man is one of Chase's close friends, the artist Robert Blum (1857–1903). The setting is believed to be Blum's garden at his home in Zandvoort, Holland, where Chase spent the summer of 1884 painting a series of plein-air landscapes. The two artists worked closely during the 1880's, especially in organizing the exhibitions of the Society of Painters in Pastel. Chase had met Blum as early as 1880 and had traveled to Spain with him in 1881 and 1882, before spending the summer of 1884 with him in Holland. Although Chase visited Holland briefly once more in 1885, he did not spend any extended time in that country again until 1903.

In the latter year, when Chase traveled to Europe to teach a summer class in Holland, he stopped in Paris beforehand to visit the Salon exhibition. While staying in Paris, he received word of Blum's death in New York. In a letter to his wife Alice, Chase lamented this great personal loss: "I can't get it out of my head. Was he sick long? Just think of his being no more." [42, p. 193] When he later reached Holland, Chase paid a visit to Blum's former house, where *A Summer Afternoon in Holland* had been painted. He wrote Alice once again: "It is too bad about Blum's taking off. I saw with keen feeling of regret the little house he occupied here. He is well remembered. . . ." [42, p. 211] Nine years later, in 1912, Chase made his last visit to Holland, at which time he visited the Zandvoort house again. He was greeted by the Dutch family who had rented the house to Blum. By this time, the young girl who appears in the hammock in *A Summer Afternoon in Holland* (and who had posed for both Blum and Chase in other works) was married and had a family of her own. [42, p. 109]

Undoubtedly, *A Summer Afternoon in Holland* was greatly valued by Chase. It was not offered for sale in the American Watercolor Exhibition of 1886. And although Chase included it in an auction of his works in 1887, it was bought back (or withdrawn) by him at $500.[38] Thereafter it remained in Chase's possesion until his own death in 1916; the following year it was sold as part of his estate sale.

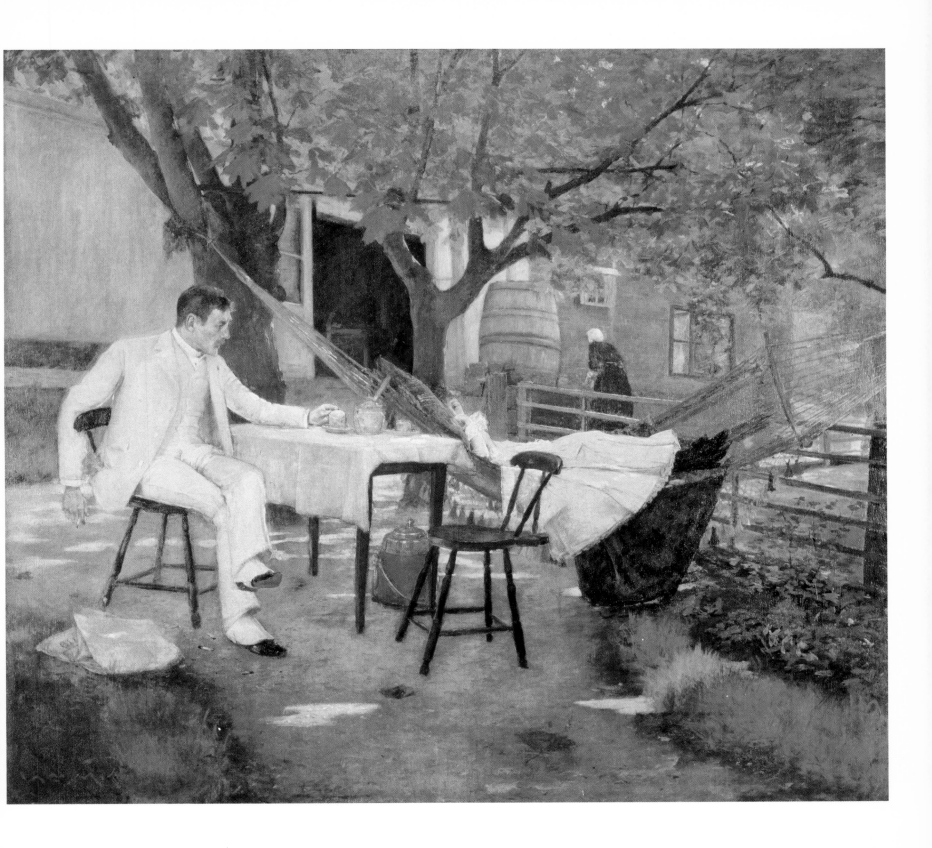

Plate 7
PORTRAIT OF THE ARTIST (SELF-PORTRAIT)
Pastel on Paper
17 1/4" X 13 1/2" (43.82 cm X 34.29 cm)
Signed
c. 1884
Collection of Mr. and Mrs. Raymond J. Horowitz

"The profession of the artist is one of the most ancient that we know, and, as I tell the students about to enter it, the most dignified." [14, p. 444]

In his art, his teaching, and his general life-style, Chase did much to gain respect and dignity for American artists. Even his manner of dress was an expression of his attitude toward art. As one of his pupils, Gifford Beal, explained: "His dress was always immaculate. I have seen him paint many times in a white flannel suit, holding a palette and brushes, without getting a spot on his clothes. . . . His dress was a part of his art psychology. As students it made us respect him the more and, in turn, respect ourselves." [7, p. 258]

In the pastel *Portrait of the Artist*, Chase has depicted himself as a debonair bachelor, at about age thirty-five, full of self-confidence and proud of his profession. He was described by a contemporary writer as having "a fine broad forehead; the features clear-cut and expressive; the eyes dark and changing; and the manner singularly sensitive, passing with rare mobility from coldness to excitement as the mood changes. The dark brown beard and moustache are carefully trimmed. . . . The dress neat and gentlemanly, not in the least the typical attire of a painter." [27]

Portrait of the Artist was included in the first exhibition of the Society of Painters in Pastel held at W. P. Moore's Gallery in 1884. This organization, formed by Chase and his friend Robert Blum in 1882, had planned for its first exhibition to open in the fall of 1883, but it was postponed until March of the following year. The works of fifteen artists were included in the premier exhibition; the most noteworthy were William Merritt Chase, Robert Blum, J. Carroll Beckwith, Edwin Blashfield, Walter Palmer, and Charles Ulrich. The general purpose of the society was to revive interest in the long-neglected art of pastel painting as a serious art form. Their exhibitions, held sporadically between 1884 and 1890,[39] were well received by art critics, who generally singled out the work of Chase and Blum for special praise. Reporting on the 1884 exhibition, one critic informed the public: "The meticulously smooth, soft and pretty effects are characteristics of conventional pastel work looked for here in vain. Instead one finds all the freedom and nearly all the vigor of oil."[40] Another critic noted, ". . . it attracted much attention, and undoubtedly went far to explain to intelligent eyes the peculiar characteristics of the process." [47, p. 207]

Chase exhibited sixteen pastels in the 1884 exhibition. This self-portrait—or simply *Portrait*, as it was titled in the catalog for the show—was consistently singled out for particular praise. It was described by one critic as "clever"; another concurred, referring to it as "so clever in pose and strong in handling as to have satisfied most artists with that one effort." [3] A third critic praised it as being "as vigorous and vehement a piece of work, both in color and handling, as any painter need desire to show in any medium whatsoever." [47, p. 208]

Although Chase painted a considerable number of self-portraits during his lifetime, only one other pastel self-portrait can be documented, and that work is either lost or destroyed.

It is interesting to note the stamp of the Society of Painters in Pastel in the upper-right quadrant of this work. Whereas many exhibitors used this skull-like monogram incorporating "PP" on the mats of framed works in the society's exhibitions, Chase chose to stamp his works directly with this curious device.

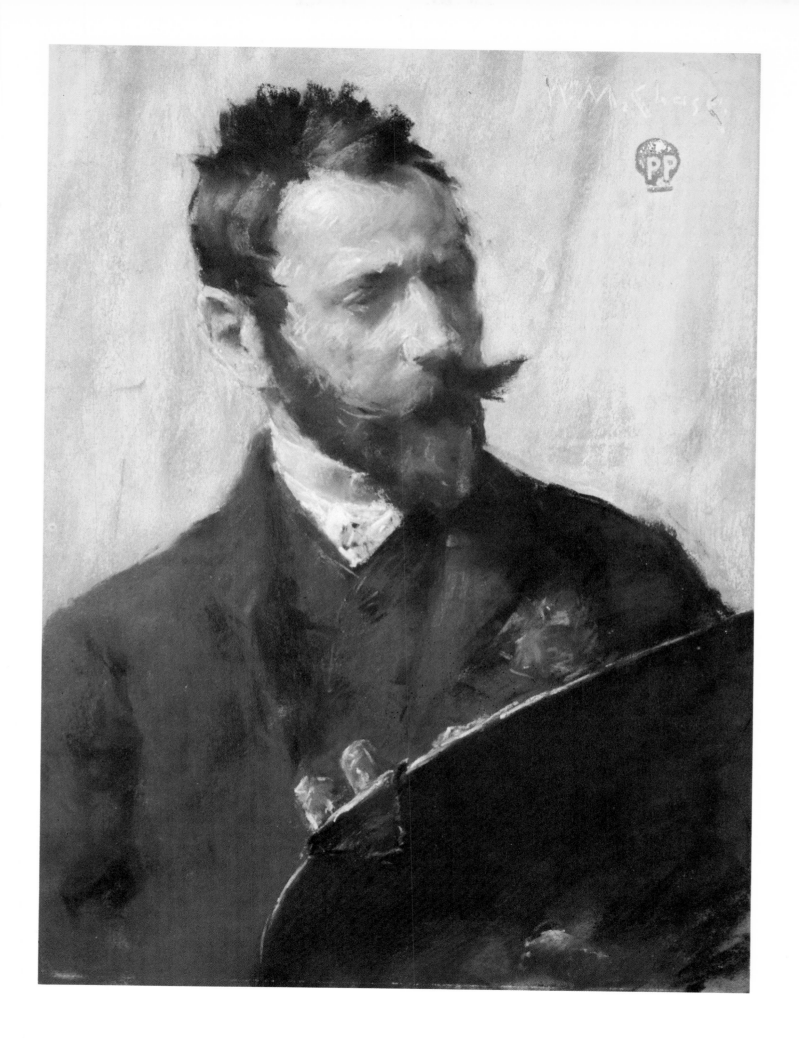

"Nothing [is] more difficult than flowers." [29, p. 436]

Chase advised his beginning students to avoid painting flowers, which he considered the most difficult of subjects. When asked "How are you ever going to do a thing unless you try it?"—he wisely replied: "By working at what you can do, until you are actually ripe for more. Then unconsciously you will do it, without any visible effort." [33, p. 141] The pastel *Flowers* clearly demonstrates Chase's own success in dealing with this difficult subject matter in an apparently effortless manner. Although Chase was highly acclaimed as a still-life painter, he was best known for his paintings of slippery fish and glistening pots and pans. The shimmering, highly reflective quality of their surfaces challenged his technical ability as a painter and inspired some of his best-known works. It is unfortunate that there are so few floral still lifes by his hand, since those we have are so lovely and avoid any degree of sentimentality—a trait too often associated with floral still-life painting.

Flowers was exhibited at the initial exhibition of the Society of Painters in Pastel, held at W. P. Moore's Gallery in New York in 1884 (catalog number 27), the first of several held by this group. The occasion was discussed in the press more than a year in advance: "It is an open secret that Chase, Blum, Dielman and a half dozen others are to give a special exhibition in pastels next spring."[41] And when the exhibition actually opened, it was well received, with Chase's work singled out for special praise: "Mr. Chase's work has the pre-eminent distinction of being always interesting. In this direction of pastel drawing it appears as if he had been engaged in proving to himself the range of his versatility and his cleverness. [3]

Chase achieved the highest and most consistent quality in his work in pastel. This may seem unusual, since as a recognized master of the brush, he was so adept at painting; and besides his pastels, he executed relatively few drawings of any sort. But there are several plausible explanations for this apparent discrepancy: with the pastel medium Chase was able to achieve bright hues and soft textures unattainable in oil; the small competitive group of the Society of Painters in Pastel inspired Chase to produce work of especially high quality; and finally, neither Chase nor the other members of the society thought of pastels as a "drawing" medium, as is clear in their choice of a name for the organization.

The contemporary critic Mariana Griswold Van Rensselaer explained the reasoning behind their insistence that pastel was a painting medium: " 'Drawing,' though it must often be used with less precision, really implies work with the point . . . the effects one seeks are effects of line, not mass. But with pastels one seeks effects of mass, not line. Either the color is completely blended with the stump or fingers . . . or if one uses the harder crayons most in favor now and their strokes remain distinct, these are comparable rather to the brush-marks of a painter than to the true lines of a draughtsman. [48]

Although The Society of Painters in Pastel only exhibited together a few times, and then only sporadically, the high quality of their work did much to revive interest in the medium. It is interesting to note that one year after the Americans' initial exhibition, a French society of pastelists was formed, including such artists as Lefebvre, Cazin, Rafaelli, and Boulanger. Commenting on this group, a New York critic reminded the public, "The idea of a society of 'pastellists' originated in New York with those clever young artists, Chase, Blum, Beckwith and company. . . ."[42]

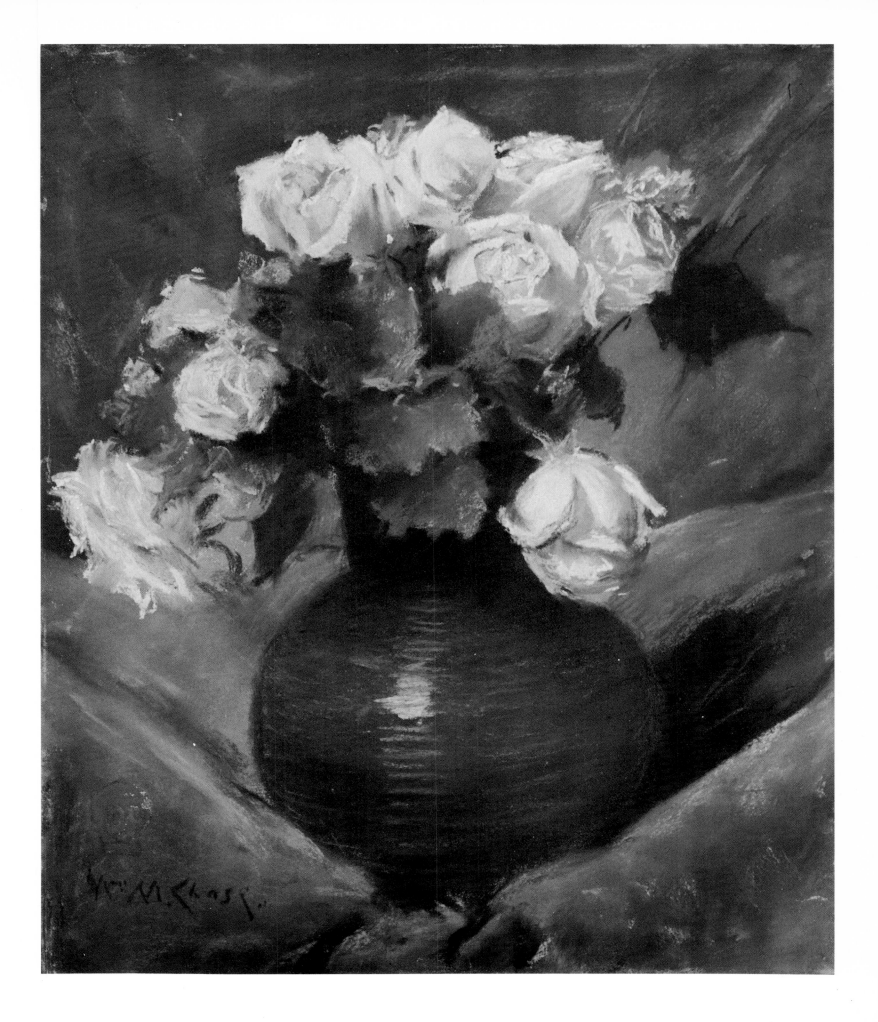

"There were two distinct sides to Whistler, each one of which made him famous. . . . One was Whistler in public—the fop, the cynic, the brilliant flippant, vain, and careless idler; the other was Whistler of the studio—the earnest, tireless, somber worker . . . endlessly striving to add to art the beautiful harmonies, the rare interpretations . . . his real self, which will live in all its glory when the man's eccentricities are utterly forgotten." [15, pp. 222, 226]

Knowing these two sides of Whistler, why did Chase choose to paint the facade rather than the real self? Or did he? No two critics agreed on Chase's exact intent or accomplishment in portraying Whistler as he did in this work. The painting was praised and damned by artists and critics alike, and it was a scandalous delight to the general public. Whistler himself denounced it as a "monstrous lampoon" when Chase began exhibiting the painting throughout America and giving regular lectures on Whistler and their brief acquaintance. Although both Chase and Whistler benefited from the extensive publicity generated by this controversial work, Whistler never forgave his fellow artist for what he considered a "mean injustice."

To understand Chase's intent in portraying Whistler as he did, and to appreciate the ensuing controversy, it is necessary to examine the brief friendship shared by these two artists during the summer of 1885, when the work was executed. Before their introduction, Chase was already a great admirer of the expatriate Whistler's art. However, he was somewhat intimidated by the stories he had heard: "I had heard much of the eccentric artist, of his sharp, ready tongue, his cruelties even to the friends he knew best, his downright insults to strangers; and drop by drop my enthusiasm trickled away. . . ." [15, p. 219] This feeling of apprehension was soon dispelled when the two artists met—not because the stories had been unfounded, but because Chase had underestimated his own keen wit. For a while, the raillery was enjoyed by both artists, and when Chase felt impelled to continue his European trip, Whistler persuaded him to stay so that they might paint each other's portraits. They agreed that whichever artist was "specially in the mood" was to paint while the other posed. Whistler, of course, was always "in the mood" and Chase was allowed little painting time for himself. Ironically, Chase completed his portrait of Whistler, while his ever-toiling comrade never finished the portrait of Chase.

The witty but gentle Chase soon grew tired of Whistler's vicious jibes, and as his stay in London drew near an end, he pleaded with the quarrel-some Whistler to let him leave England with a pleasant impression of him while it still remained. Whistler retorted, "You don't seem to understand. It is commonplace, not to say vulgar, to quarrel with your enemies. Quarrel with your friends . . . that's the thing to do." [15, p. 224] When Chase finally did leave for Amsterdam, he made the mistake of asking Whistler to join him. They argued during the entire trip, until Chase asserted that one of them would have to get off at the next train station, which was Haarlem. Whistler agreed, calmly responding, "Yes, colonel [as he liked to call Chase for some unexplained reason]; you get out." [15, p. 225] Thus ended their brief and tumultuous relationship. Chase saw Whistler one more time, the next day in Amsterdam, before returning to the United States to exhibit what would be a much-disputed memento of their encounter, his portrait of Whistler.

The painting was exhibited in Boston and in New York, and then all over the country. Critics described it both as a caricature of Whistler and his style of painting and as a true rendition of the expatriate's personality. One referred to it as "a smoky vision which leaves a vivid impression of a long lanky form, a Mephistophelean face surmounted by a white plume, and a long wand."[43] Another praised it as "the harsh truth—neither more or less."[44] Chase probably agreed with both.

It is unlikely that Chase was actually mimicking Whistler's style of painting in this work.[45] The deliberate Whistlerian qualities of the work were more likely a tribute to this artist, whose work Chase greatly respected. It was a common practice of Munich-trained artists to paint portraits of their fellow artists in the style practiced by the artist who was posing. Of course, this technical feat also called attention to Chase's versatile skill in painting in the style of any artist he chose. It is also unlikely that Chase intended this work to be a caricature of Whistler. It was meant, instead, to be a form of repartee—an extension of their witty personal exchanges during the summer of 1885.

It is interesting to note that, although Whistler had requested that Chase not exhibit the portrait until his own portrait of his colleague was completed, he did not seem to express any serious objection to the work until after it was exhibited and the critics pointed out what they believed to be a sham. He never forgave Chase and complained bitterly about the situation to anyone who would listen. But nothing could be done. Recalling his days in London with Whistler while the work was painted, Chase later noted: "It was good to get even with him in repartee. It was rarely possible. . . ." [15, p. 220] Whether he knew it or not when he painted this work, Chase was one of the very few who encountered the flippant dandy of Cheyne Walk and had the last word.

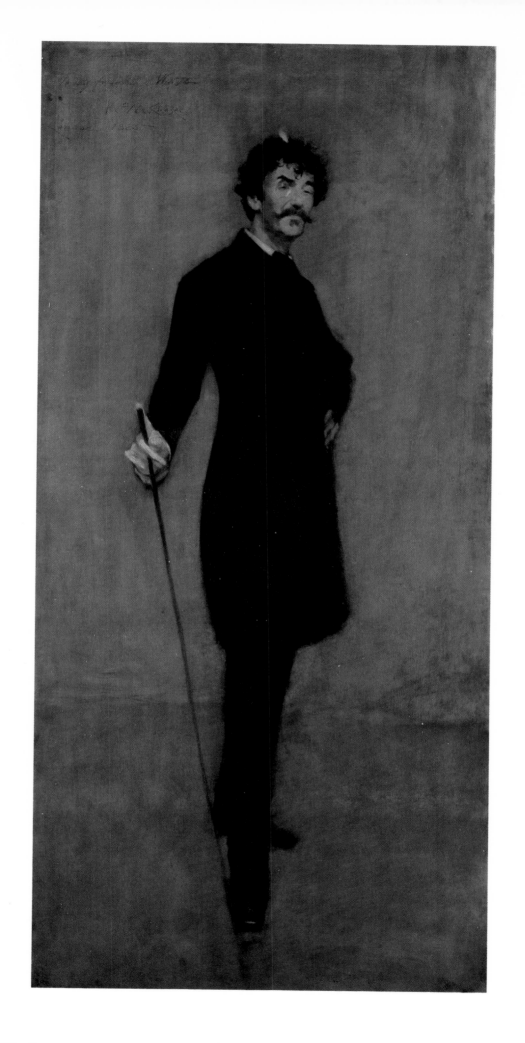

Plate 10
THE WHITE ROSE (MISS JESSUP)
Pastel on Canvas
69" X 39" (175.26 cm X 99.06 cm)
Signed
c. 1886
Collection of the Phoenix Art Museum, Phoenix, Arizona
(Gift of Miss Margaret Mallory)

"One becomes in time so sensitive to color harmony that the instant one puts on a false spot of color it hurts, like the wrong note in music." [29, p. 433]

Like Whistler, Chase often used musical terms to describe his art or to explain certain aspects relating to the way he painted. For example, he instructed his pupils, "Look for the whole thing, the ensemble. I wish I had a phonograph here to grind out 'Ensemble—Ensemble' every minute." [33, p. 139] Using this simile, *The White Rose* might be described as an "ensemble in white." Almost monochromatic, its subtle gradations of color combine with the soft quality of the pastel medium to create a delicate and harmonious statement. While this pastel's grand scale alone qualifies it as one of the highest expressions of technical ability in nineteenth-century American art, it is ultimately one of the masterpieces of pastel painting ever created in this country.

The silvery tones in *The White Rose* illustrate Chase's preference for a white that has been toned down to achieve a softer, more harmonious shade—a preference made clear in the advice he gave his pupils: "White seldom occurs in a subject. At one time I refrained from having it on my palette—made a grey (lamp-black, white, and yellow ochre), and when go-

ing on a trip asked my color dealer to have a number of tubes of it prepared. On my return I found he had been selling it—called it 'Chase Grey.' You can imagine my feelings—Rubens Madder, Vandyck [sic] Brown, and Chase Grey!" [29, p. 436]

Although this work might be compared to similar subjects by Whistler, its grand scale and more finished quality relate it directly to the pastels of the nineteenth-century Italian artist Giuseppe De Nittis. The contemporary critic Mariana Griswold Van Rensselaer first noted De Nittis' important influence on the development of pastel painting in America in the early 1880's: "Mr. Whistler gave it a fresh impulse and popularity with his exquisite, subtle, yet freely handled and brilliantly colored Venetian studies. And finally, De Nittis showed that it was suitable for the most ambitious efforts. Single figures of large size were common, it is true, in the eighteenth century; but De Nittis paints elaborate compositions in which the strongest color, the most difficult effects, and the most powerful handling are attempted." [47, p. 207] Chase was not only aware of De Nittis' work but owned one of his smaller compositions.[46]

The model for *The White Rose* is purportedly one of Chase's female pupils,[47] Miss Jessup—possibly Josephine Jessup (1858–1933), a miniature painter. It was not unusual for Chase to use his female students as models; others who served for major paintings include: Lydia Field Emmet, Annie Traquair Lang, and Mariette (Mrs. Leslie) Cotton, who posed for *Lady in Pink* (Rhode Island School of Design, Providence).

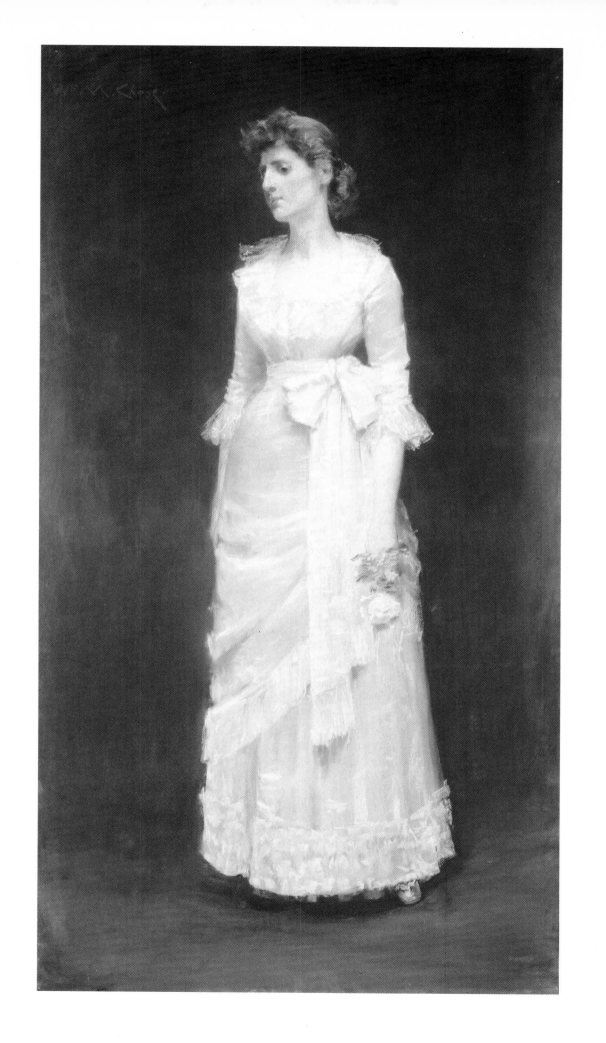

"In portraiture they [artists] deal with character and individuality. Each sitter presents some new phase of personality that no one has ever done before. There is constant variety, constant study in the work." [48]

Chase's model for *Meditation* was Alice Gerson, who would soon afterward become Mrs. William Merritt Chase. Both before and after their marriage, she served as a frequent and patient model for the artist, as well as a constant source of artistic inspiration. In this masterful pastel she is depicted at about age nineteen; and although Chase has truthfully portrayed her childlike features, he has also managed to capture her womanly charm. In an announcement of their marriage made shortly after this pastel was completed, a newspaper report described her as "a handsome and spirited brunette of a good family." The writer then went on to comment on this pastel portrait of her: "No special attempt has been made to conceal the likeness, so that the reproduction of Mrs. Chase's features is exceedingly faithful. Her figure is lithe and well rounded, and altogether she has the quality attaching to all models, which is described among artists as paintable." [49] This writer also noted that although the subject of artists' marrying their models was popular with novelists, it was in reality a rare event.

Alice Gerson was one of three daughters (and a son) born to Mr. and Mrs. Julius Gerson. By the time Chase was first introduced to the family, Mrs. Gerson had already died. It was a cultured family with artistic interests. Alice and her sisters Virginia and Minnie frequently posed for the young artists who visited their father and who could not afford the services of professional models. Virginia was also a writer and costume designer; and their younger brother often entertained the group with music. Among the artists who frequented the Gerson home were Walter Shirlaw, Frederick Dielman, Napoleon Sarony, James Kelly, Robert Blum, and Frederick S. Church. It was Church who introduced Chase to the group, at the prompting of the Gerson girls, who had been greatly impressed by Chase's painting *Ready for the Ride* and were eager to meet the young artist. At his first visit to the Gerson home, Chase was affected by the warmth and kindness of the family and was particularly charmed by Alice, whom he asked to model for him. Six years later, in 1886, they were married. [42] Even then it came as something of a surprise to Chase's artist friends, who regarded him as "a bachelor of the most confirmed type." [50] At the time of their marriage, Alice was twenty years old and Chase was thirty-one. During their thirty years of happily married life, they had nine children, one of whom (William Merritt Jr.) died in infancy. All the children, along with their mother, served frequently as Chase's models and appear in many of his most popular paintings.

Meditation is probably Chase's most widely exhibited pastel. It was awarded a medal when exhibited at the Crystal Palace International Exhibition in 1892 and was often singled out for praise by contemporary art critics, who described it as "earnest, sustained and perfectly natural . . ." [51] and "a sympathetic and refined interpretation of womanly character." [20, p. 307] A personal statement with wide general appeal, it is simple and forceful in its directness.

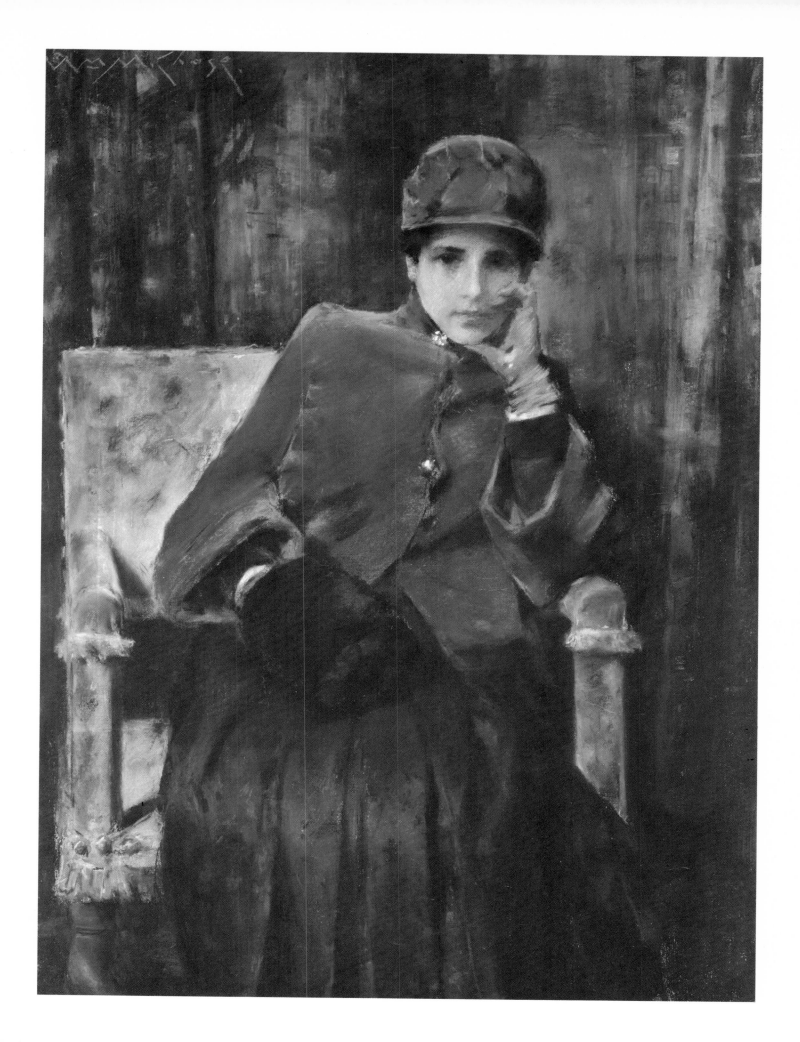

Plate 12
PROSPECT PARK
Oil on Canvas
13 5/8" X 19 5/8" (34.61 cm X 49.85 cm)
Signed
c. 1885/1886
Courtesy of the Art Institute of Chicago
(Bequest of John J. Ireland)

"There are some charming bits in Central Park and Prospect Park, Brooklyn. In the latter place you used to have to get a permit in order to sketch. . . ." [28]

While living in Brooklyn, William Merritt Chase often frequented Prospect Park, the setting for many of his landscape compositions of the late 1880's. James Pattison, a contemporary writer and an acquaintance of Chase, recalled in an article: "A few years ago, Mr. Chase lived in Brooklyn, and wandered into the nearby park, sitting down almost anywhere on the lawn, beside the park road, with one or more buildings in sight. The canvases being small, one half day was devoted to each. His aim was to catch the sense of outdoor light and air." [39]

Prospect Park had been designed by Frederick Law Olmsted and Calvert Vaux as a place where "Men must come together, and must be seen coming together, in carriages, on horseback and on foot, and the concourse of animated life which will thus be formed must in itself be made, if possible, an attractive and diverting spectacle."[52] The success of their achievement is well recorded in the many small scenes of the park painted by William Merritt Chase, scenes depicting the diversions of everyday life in the city during the last decade of the nineteenth century.

In the painting *Prospect Park*, Chase presents a woman seated on a park bench, with several figures and a game of lawn tennis visible in the distance. Lawn tennis was a "removable activity" (in that the area could also be used for croquet, bowling, or a Maypole), a versatile use of space provided for in the park's plans.

In laying out the walkways as a series of vantage points for appreciating the carefully designed splendor of the park's landscaping, Olmsted and Vaux also created an artist's haven. One of the first to realize this, Chase took full advantage by painting the park from every angle; what seemed to be pedestrian subject matter for other artists inspired some of Chase's most beautiful paintings. In retrospect, it is difficult to imagine these works as being innovative or a venturesome departure from the usual subject matter for landscape artists. But they were considered as such at the time, as evidenced in a sympathetic review by one critic, who wrote: "It was Chase who dared to paint the smug symmetries of a public park landscape. . . ." [31]

The broad expanse of foreground in *Prospect Park* and the strong diagonal leading to the focal point of the picture are compositional devices often used by the artist to draw the viewer into the picture plane. The openness of these compositions and the warm light in which Chase bathes his summer landscapes are inviting factors that have helped make these paintings universally appealing. A very similar view, but painted from the opposite side of the Concourse, is in the collection of the Colby College Art Museum (Waterville, Maine).

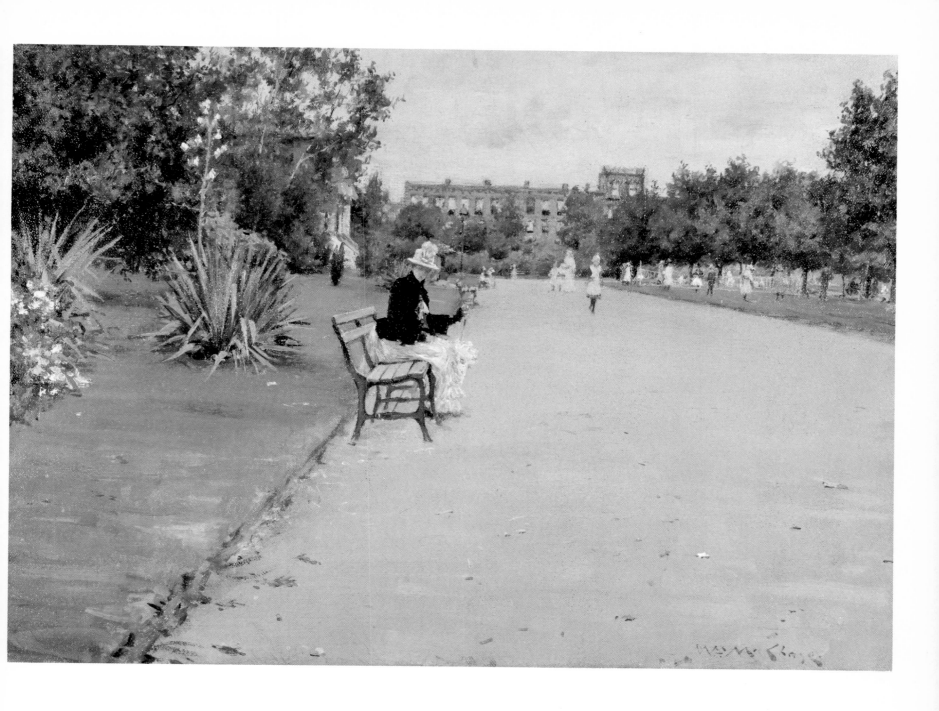

Plate 13
MRS. CHASE IN PROSPECT PARK
Oil on Wood Panel
13 3/4" X 19 3/4" (34.93 cm X 50.17 cm)
Signed
c. 1886/1887
The Metropolitan Museum of Art (Gift of Chester Dale, 1963)

"If you do give [away your work], let it be the very best you have."
[29, p. 434]

Inscribed works by artists are special works in many respects. They give a better understanding of the personal aspect of an artist's career and, as in this case, attest to the sincere friendship of two fellow artists, Chase and J. Carroll Beckwith, to whom this work is inscribed. It is quite possible that Beckwith had accompanied Chase on the painting excursion to Prospect Park when *Mrs. Chase in Prospect Park* was painted, and that it was presented to him at the end of the day's work. Beckwith, too, was definitely known to have completed park scenes around the same time.

The two artists had first met in the autumn of 1878 when they were returning to New York from studies abroad, Chase from Munich and Beckwith from Paris. During the 1880's a close friendship developed. They both taught at the newly founded Art Students League in New York, exhibited at the Society of American Artists, and were members of the Society of Painters in Pastel. They also belonged to the Art Club, a small group of young artists who met at The Studio, a chophouse on Sixth Avenue. As early as 1881 or 1882, Beckwith painted a full-length standing portrait of Chase (Indianapolis Museum of Art); and in 1884 Chase inscribed *A Bit of Green in Holland* (The Parrish Art Museum, Southampton, N.Y.) to his friend Beckwith. The two artists remained friends throughout their lives (Beckwith died in 1917), but it is unlikely they were ever closer than during the early years. In a letter to Chase dated a few months before he died, Beckwith wrote of "Those old days, when you and Blum and I used to be pals."[53]

Mrs. Chase in Prospect Park, a charming vignette depicting the artist's young wife Alice Gerson Chase (c. 1866–1927), was painted shortly after they were married in 1886. At the time the newlyweds were living in Brooklyn, and Chase took full advantage of the nearby park as the setting for many of his outdoor compositions. Alice, who had also served as his model prior to their marriage, continued to be a source of inspiration throughout the artist's career and appeared in many of his figure studies, landscapes, and interior scenes. Like all of Chase's landscape paintings, this work was painted on the spot, directly from nature.

In describing his method of painting such a work, the artist explained: "When I start to paint out of doors, I put myself in as light marching order as possible; that is, I have everything made as portable and with as little weight as it can be. I have a light color box, and take no more colors than I think I shall be sure to need ... I carry a comfortable stool that can be closed up in a small space and I never use an umbrella. I want all the light I can get. When I have found the spot I like, I set up my easel and paint the picture on the spot. I think that is the only way rightly to interpret nature." [28]

Chase, in explaining what he strove for in these compositions, described the process as re-creating the harmony he saw in nature. *Mrs. Chase in Prospect Park* displays both the artist's interest in light (as seen in the flickering light reflected in the water) and his concern for creating a harmonious composition, as evidenced by his limited scale of color used in subtle tonal gradations.

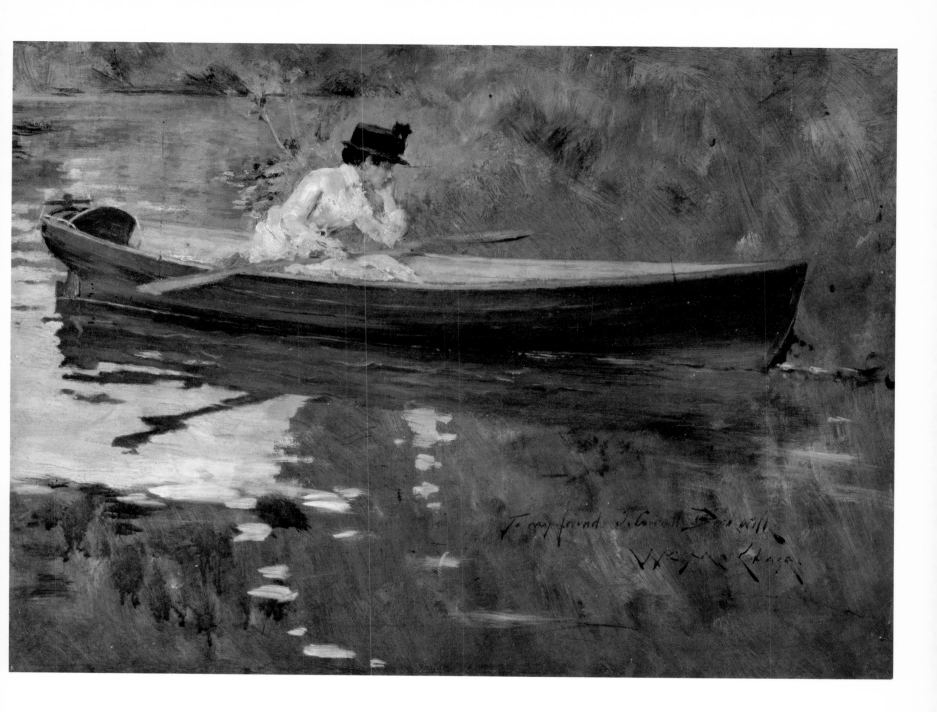

"A delicate subject requires vigorous treatment to avoid bon-bon type." [29, p. 433]

In response to a challenge from several fellow artists, who acknowledged Chase's general versatility with regard to subject matter but claimed that "painting the nude figure was not in his line," Chase completed a series of pastel studies of the nude in the mid-1880's.[54] Although it is difficult to distinguish one from another on the basis of contemporary exhibition reviews, these works were generally well received by the art critics. When two were exhibited in the 1884 exhibition of the Society of Painters in Pastel, one critic extolled them as "shining examples of the solidity of forms, weight of light and shade in fullness of color attainable by a really accomplished artist in pastel."[55] Another work in this series, exhibited at the society's 1888 exhibition, was singled out as the most important work in the show and was praised for its solid treatment and brilliant color. [48]

The artist Kenyon Cox recalled his reaction to this series of nudes by Chase: "Within a short time some of us have seen a few lovely pastels of the nude female form from his hand. The delicate feeling for color and for value, the masterly handling of the material, the charm of texture in skin or stuffs—these things we were prepared for; but we were not quite prepared for the fine and delicate drawing, the grace of undulating contour, the solid constructive merit which seemed to us a new element in his work." [21, p. 557]

While Chase did not continue this theme as subject matter, he held firmly to his belief that the nude should be realistically portrayed rather than idealized. One critic disagreed: "In the court proceedings, in the matter of 'Living Bronze Statues' it astonished me to read that in Mr. Chase's opinion a public exhibition of nude women would help to educate the public in art. Artists, as a rule, certainly will not agree with him. In painting and sculptue, the study of the nude living model of course is a necessity; but painters and sculptors do not 'copy' the model—they idealize it. That is art."[56] Chase placed little value on the views of art critics, or even on the taste of the general public, as he explained to his pupils: "I am never so disappointed with my work as when it meets the approval of the public." [33, p. 135]

In terms of technical skill, Chase's brilliance was never challenged. If anything, he was criticized for using his art as a means for displaying his skill, even flaunting it. But for Chase, technique was the means by which he could keep a truthful statement interesting, and his work in pastel was yet another medium in which he could explore this ability. Indeed, along with his friend Robert Blum, he was recognized as the foremost pastelist in the country. During the 1880's the medium had been greatly improved; new colors were available, and fixatives allowed artists to work color upon color without "muddying" their shades.

It is no wonder that the medium attracted Chase, with his vital approach and dashing manner, as well as his concern for color. Joseph Pennell, a fellow artist, pointed out the advantages of pastel: "There is no mixing them with oil or water, for they are mixed. There is no waiting for them to dry and then seeing what unexpected effect they will present, for they are dry. Once they are put upon the . . . paper, they stay there just as they are. There is no varnishing to bring out the color and no restoring is wanted since the colors never fade. There is no oil in them to turn black, nor will sun bleach them out."[57] While pastels are more fragile than implied in this critique, *Back of a Nude* has survived intact as a premier example of pastel drawing in America. It is also one of Chase's most enduring and well-known works.

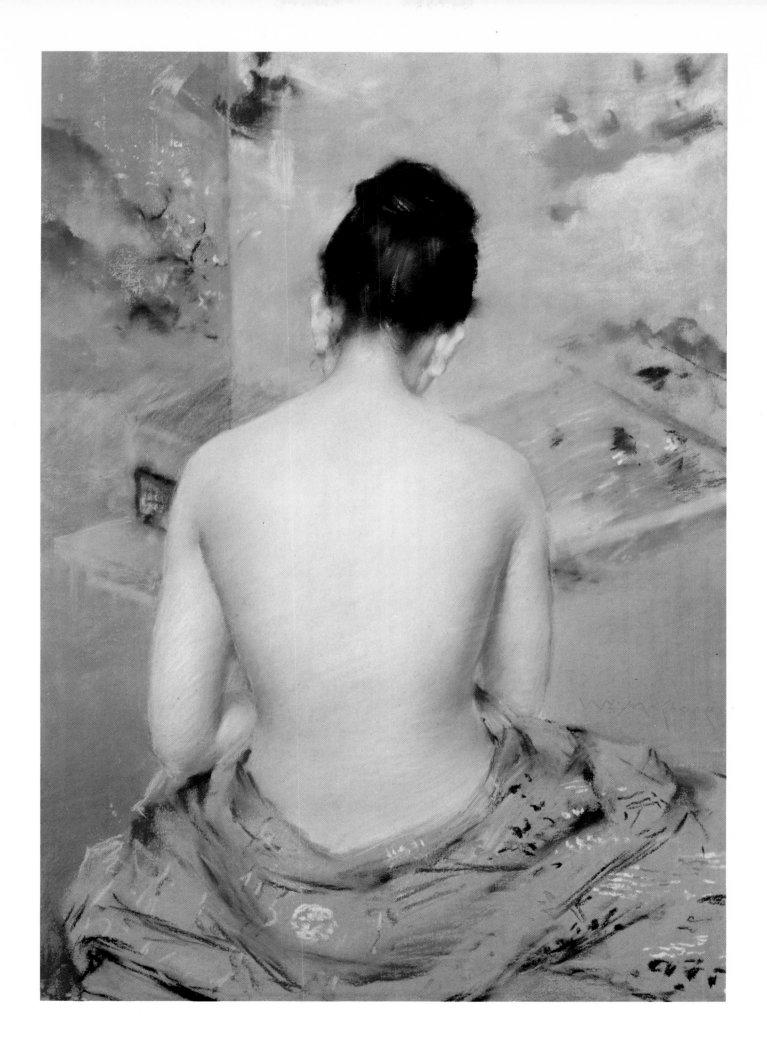

Plate 15

Plate 15
THE OPEN-AIR BREAKFAST (THE BACKYARD: BREAKFAST OUT-OF-DOORS)
Oil on Canvas
37 1/2" X 56 3/4" (95.25 cm X 144.15 cm)
Signed
c. 1888
The Toledo Museum of Art, Toledo, Ohio
(Gift of Florence Scott Libbey)

"How much light there is out of doors. Look out of the window and note how light the darkest spots in the landscape are in comparison with the sash of the window." [33, p. 135]

In 1881, during a trip to Paris, Chase met for the first time the Belgian artist Alfred Stevens, whose work he had greatly admired. Stevens had equal praise for Chase's painting *The Smoker*, which had been awarded honorable mention at the Paris Salon of that year. He had one criticism, however: that Chase was too concerned with making his work look like that of the Old Masters. This comment was taken to heart by the Munich-trained Chase, who upon returning to America abandoned the use of bitumen (a substance he had used to give his work an Old Master effect). As a result, his work became brighter, fresher, and more colorful.

During this period, Chase also became more interested in landscape painting, a subject he had rarely treated prior to this time. In 1884 Chase spent the summer painting with his friend Robert Blum in Holland, where he completed his painting *Sunlight and Shadow*. The two artists worked closely during this period, both in painting and in pastel. Chase's own work in pastel had the enlivening effect of heightening his palette.

The Open-air Breakfast, painted about 1888, is stylistically and thematically a continuation of Chase's artistic development in Holland and shows the results of his experimentation with the pastel medium. In its use of pastel-like colors and concentration on light and atmosphere, it is very similar to *Sunlight and Shadow*, painted four years earlier. *Sunlight and Shadow* depicts Chase's friend Robert Blum in the garden of his summer home in Holland; *The Open-air Breakfast*, more telescopic in view, portrays Chase's family in the backyard of his own home in Brooklyn. In both works Chase has managed to capture leisurely moments with unerring grace and style.

Seated at the table in this painting is Chase's wife Alice, with their first child Alice Dieudonnée. Reclining in the hammock is the artist's sister-in-law Virginia Gerson, and standing in front of the Japanese screen is Chase's sister Hattie. The artistic trappings, decoratively arrayed for the pleasure of the participants in this scene as well as for the viewer, reflect Chase's aesthetic milieu. He once directed his students to "Seek to be artistic in every way." [29, p. 437] His style of living reflects his own adherence to this principle.

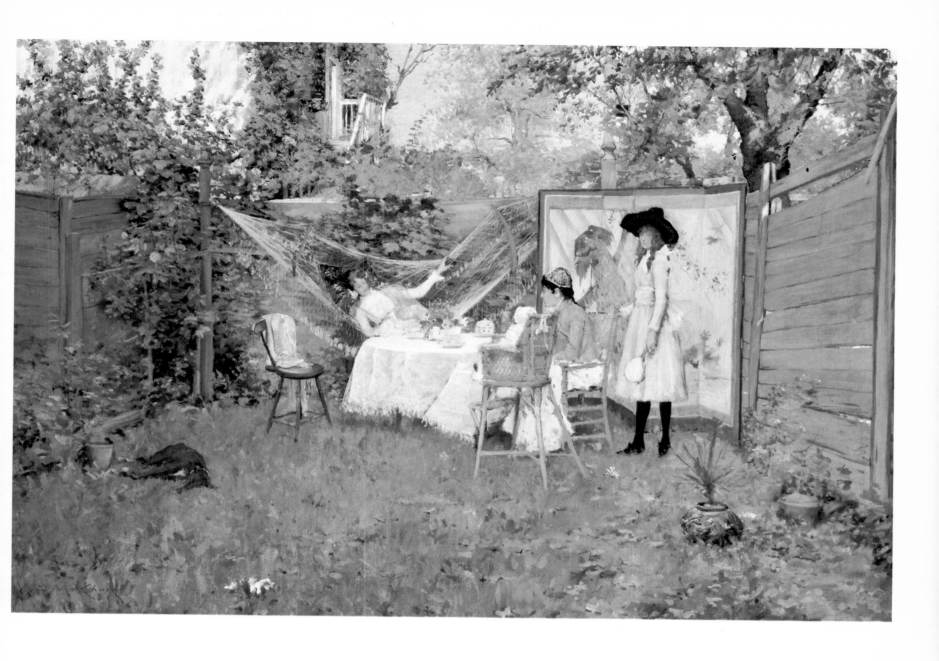

Plate 16
PORTRAIT OF A LADY IN PINK
Oil on Canvas
70" X 40 1/2" (177.8 cm X 102.87 cm)
Signed
c. 1888/1889
Museum of Art, Rhode Island School of Design, Providence
(Gift of Isaac C. Bates, April 1894)

"There is hardly a portrait painter who lives who does not paint in his mind every person whom he meets. The ideal face and the face that does not reach the standard of beauty are alike in his imaginary sketching, and he obtains enjoyment from each." [36]

The ideal face in *Portrait of a Lady in Pink* is that of Mariette Benedict Cotton (1868–1947), one of Chase's students. Miss Cotton was also the model for his painting *Lady in Black* (Metropolitan Museum of Art), completed shortly before this work was begun. In describing the circumstances of their first meeting, Chase recounted: "One morning a young lady came into my Tenth Street studio, just as I was leaving for an art class in Brooklyn. She came as a pupil, but the moment she appeared before me I saw her only as a splendid model. Half way to the elevated station I stopped, hastened back, and overtook her. She consented to sit for me. . . . Such a model is a treasure-find."[58]

As a master technician and an advocate of the principle of "art for art's sake," Chase "carried his picture making into his portraiture."[59] Works such as *Portrait of a Lady in Pink* were meant to be more than mere likenesses of their subjects; they were intended to be works of art in and of themselves. Chase was more than an artist—he was a connoisseur, whose appreciation of all that was beautiful and aesthetically appealing is conveyed in his art. He admired the textures and delicate patterns of fine fabrics just as he valued the delicate beauty of a young lady. To bring these elements together harmoniously in a painting was to him an artistic triumph, an ensemble of consummate beauty.

In his painting *Portrait of a Lady in Pink*, Chase has blended these qualities to create a sensitive and well-balanced composition. The young Mariette, who would later become a successful portrait painter in her own right, is portrayed as a refined yet vital woman. Although this work is obviously indebted to Whistler, both in its subtle tonalities and decorative patterns, Chase's painting reveals a greater concern with form, as seen in the modeling of the sitter's arms and face. It is harmonious and refined in "true Whistler fashion," but also "clever," the mark of Chase's own style; it is lush, full-blooded and spirited, enlivened and energized by Chase's vigorous brushwork.

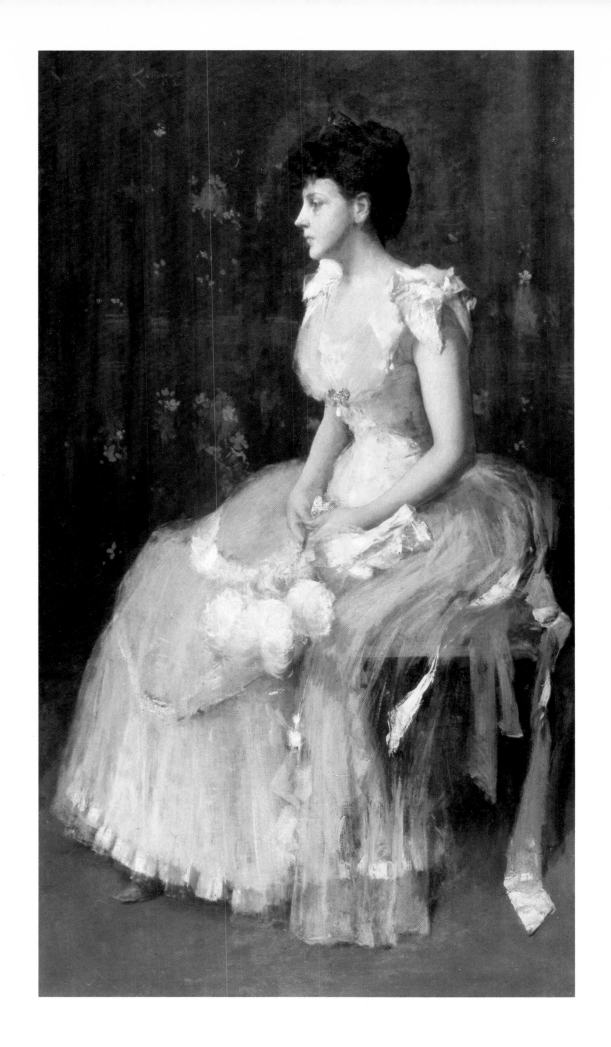

Plate 17
CARMENCITA
Oil on Canvas
70" X 40 1/8" (177.8 cm X 101.92 cm)
Signed
c. 1890
The Metropolitan Museum of Art
(Gift of Sir William Van Horne, 1906)

"It is the personality that inspires and which you depict upon the canvas. . . . To make a vivid personality glow, speak, live upon the canvas—that is the artist's triumph." [23, p. xxx]

No single work by Chase better expresses the above dictum than his painting of Carmencita, "The Pearl of Seville," who dazzled audiences on the Continent in the 1880's and, in 1890, stunned New Yorkers with spirited performances of her native Spanish dances.[60] Her fiery personality, picturesque costume, and frenzied movement particularly attracted the attention of American artists. Both J. Carroll Beckwith and John Singer Sargent arranged for her to perform in their studios before small gatherings of select guests. In March of 1890, Sargent, who was in the process of painting a portrait of Carmencita (Musée National d'Art Moderne, Paris), wrote to Chase suggesting a grand performance in his celebrated Tenth Street studio. The event would be sponsored by the two artists and Mrs. Jack Gardiner, a prominent Boston art collector and patron. Sargent explained, "Mrs. Jack Gardiner, whom I daresay you know, writes me that she must see the Carmencita and asks me to write her to dance for some day next week and she will come up from Boston, but my studio is impossible. . . . Would you be willing to lend your studio for the purpose and be our host for Tuesday night or Thursday of next week? . . . your studio would be a stunning place." [42, p. 156]

Of course, Chase was willing, and the memorable event was set for April 1, 1890. Rosina Emmett Sherwood, a guest at this festive affair, later recalled the inauspicious start of the evening. When Carmencita arrived at the studio, her makeup was garish and her hair disheveled. "Sargent and Chase made her rub the make-up off her face, and brush her frizzed hair back from her forehead. . . ." [42, p. 156] The rest of the evening proceeded without mishap; Carmencita was a magnificent success. Bouquets of flowers were showered upon her, and women tore off their jewels and threw them to the stage.

One result of this terpsichorean display (in addition to a second performance at the Tenth Street studio) was Chase's animated portrait of the lively Spanish dancer. It has been suggested that this work was painted by Chase in an attempt to rival Sargent's portrait of Carmencita. It should be pointed out, however, that Chase did not "use" this work for that purpose. Unlike his controversial portrait of Whistler (Metropolitan Museum of Art), *Carmencita* was rarely exhibited by Chase. In fact, only one documented exibition during Chase's lifetime can be found for this painting.[61] More likely, Chase was genuinely inspired by the vital nature of this dancer's volatile personality and her brisk flashing movements, attributes well suited for his equally dynamic style of painting.

In any event, Chase's animated rendition of the Spanish dancer is totally dissimilar to Sargent's sedate and monumental conception, which is itself indebted to Manet's earlier portrayal of *Lola de Valence* (1862, Louvre). Unlike the works of these two artists, who present the dancer rather as an icon, in strong but static poses, Chase's painting successfully captures her highly individual personality and the fleeting moment of an actual event. Carmencita is depicted in gyrating motion, arms flying, castanets clicking, and feet tapping, with her sash sailing in the air and a bracelet gliding across the stage. Chase vividly conveys to us the original inspiration and re-creates on canvas the excitement of that memorable night and of Carmencita herself, "The Pearl of Seville" and the delight of New York society.

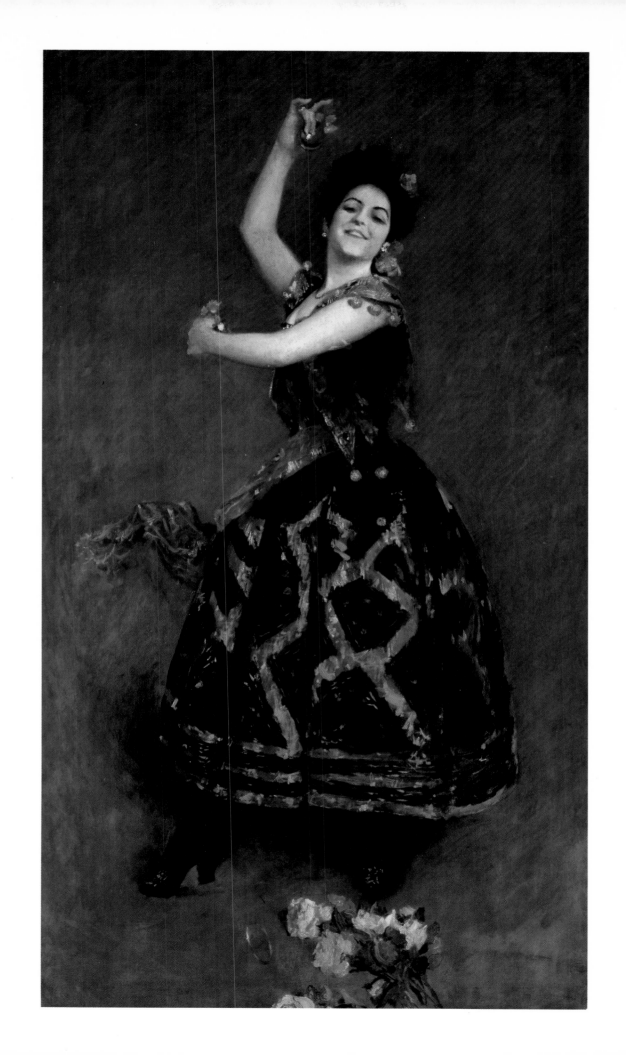

Plate 18
THE NURSERY
Oil on Paper
14 1/2" X 16" (36.83 cm X 40.64 cm)
Signed
c. 1890
Collection of Margaret Newhouse, New York

"If you want to know of good places to sketch in the vicinity of New York, I think I could easier tell you where they are not than where they are." [28]

During the late 1880's, Chase received critical acclaim for his crisply painted views of Prospect Park in Brooklyn and the surrounding countryside. In 1890, he extended the boundaries of his painting grounds to include the lovely gardens and picturesque paths of New York's Central Park. At a time when most American artists were traveling abroad to find suitable subject matter, these New York scenes were highly praised for their American spirit and were used to prove that American artists did indeed have subjects worthy of painting in their own country.

The Nursey, as described by a contemporary critic, "is a spot seen from the cars of the Hudson River Railroad, little frequented save by those who live near 100th Street. Here flowers are raised for subseqeunt transplanting to other parts of the park. . . . The view is taken from the south. Just beyond the locust trees is the winding piece of water called Harlem Lake and on the other side of the heavy foliage in the left center lies the old redoubt. The lady in front has obtained a dispensation from the rule not to pick flowers." [22]

The small paintings in this series of park scenes were described as "veritable little jewels" by Kenyon Cox, a contemporary artist and writer on art. Referring to these works, Cox proclaimed, "It is new proof if proof were wanted, that it is not subjects that are lacking in this country, but eyes to see them with. Let no artist again complain of lack of material when such things as these are to be seen at his very door, and let the public cease complaining of the un-American quality of American art, at least until they have snatched up every one of these marvelous little masterpieces." [21, p. 556]

Although *The Nursery* might be compared to similar scenes by the Belgian artist Alfred Stevens in its refinement and briskly painted style, it lacks the sentimentality found in Stevens' work. Chase's landscapes are more straightforward, uncomplicated with romantic overtones. Chase considered himself a "realist," and his paintings were on-the-spot studies of everyday "real" life. Admittedly beautiful, *The Nursery* is also more: a bold, strong visual statement with daring diagonals and masterful brushwork. Furthermore, unlike the overly refined and studied posture of women in Stevens' paintings, the placement of Chase's female subjects in *The Nursery* is handled with greater ease; they are more relaxed, with a more casual air of elegance.

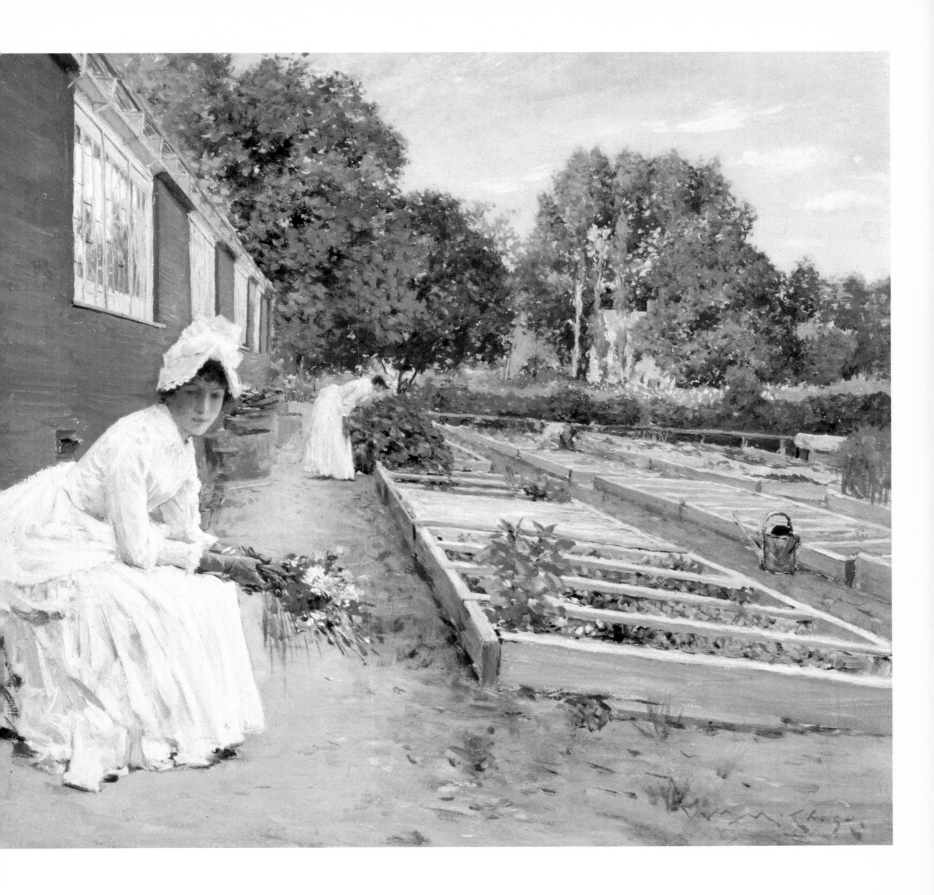

Plate 19
THE FAIRY TALE (A SUMMER DAY)
Oil on Canvas
16 1/2" X 24 1/2" (41.91 cm X 62.23 cm)
Signed
c. 1892
Collection Mr. and Mrs. Raymond J. Horowitz

"Great work comes from the heart. When only from the head, it is uninteresting." [29, p. 434]

William Merritt Chase considered himself a "realist," strongly opposed to sentimentality in art. He lectured to his pupils that "sentiment in art is passé." [29, p. 437] However, he was also opposed to mere reportage in art, which he felt should be relegated to illustrations for books and periodicals. Although he appreciated Robert Henri and his circle as painters, Chase disapproved of the narrative aspect of their art. Chase's own art, such as his painting *The Fairy Tale*, was more personal; and his concern with revealing the beauty in everyday subjects was diametrically opposite the approach of the Henri group. Expressing his disapproval of these artists who painted the unseemly side of life, Chase referred to them as "The Depressionists."

Chase was described by the painter Kenyon Cox as "a wonderful human camera—a seeing machine—walking up and down in the world, and in the humblest things as in the finest, discovering and fixing for us the beauties we had else no thought of." [21, p. 549] In *The Fairy Tale*, Chase has chosen to focus on a charming yet simple subject: his wife and their second daughter, Koto Robertine, seated in the Shinnecock dunes near their summer house. In contrasting the delicate nature of his subject to the strong and vigorously painted landscape in which the two figures are set, Chase has managed to keep a poetic theme from becoming overly sentimental. One of his major concerns in this work, as suggested by the painting's alternate title *A Summer Day*, was to capture the special quality of light and atmosphere on this particular day at the Long Island seashore. In his sure, spirited brushstrokes and fresh, clear color, he succeeded in creating a vital and direct expressive statement, beautiful yet unsentimental, and uncomplicated by any literary meaning or message. It is altogether a work that came from the heart.

While Chase's Shinnecock scenes were always well received by contemporary art critics, *The Fairy Tale* especially impressed one, who on seeing it shortly after its completion predicted, "When it comes to be exhibited, I shall expect to see larger crowds before it than landscapes usually attract." [43, p. 11] He also commented, "No one could give any idea by mere description of the poetic beauty of this lovely picture. . . ." Shortly after completing this painting, Chase painted another work, *A Study*, in which he depicted his wife Alice seated in front of *The Fairy Tale*—thus creating in effect a painting within a painting. [43, p. 9]

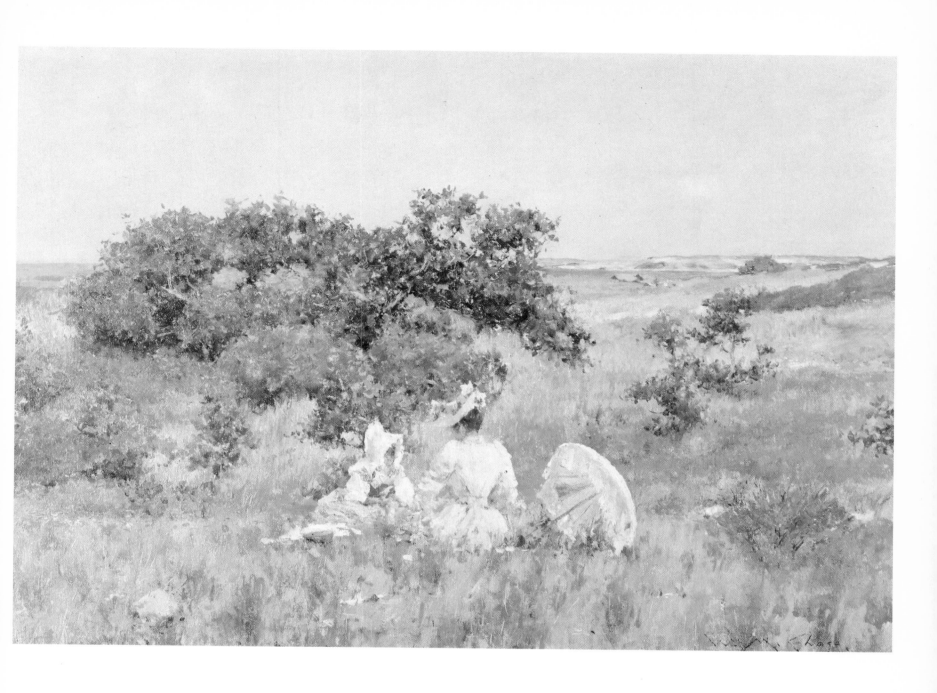

Plate 20
THE BAYBERRY BUSH (CHASE HOMESTEAD: SHINNECOCK HILLS)
Oil on Canvas
25 1/2" X 33 1/8" (64.77 cm X 84.14 cm)
Signed
c. 1895
Parrish Art Museum, Southampton, New York
(Littlejohn Collection)

"Many people say we have no school of art in America; but I do not agree with them. The studies of our Shinnecock School which cover these walls tonight are representative of American art. There is no staining, no tinting, but here is American painting which will produce good results. Let me urge you to strive to prove that our American art is a vital thing." [13]

This proclamation made by Chase in 1897 was part of a talk delivered at the annual exhibition of paintings by students of the Shinnecock summer art school. Established in 1891, this school was the first important outdoor summer art school of its kind in America. The preceding summer Chase had been invited to Southampton by Mrs. William Hoyt to discuss the possibility of founding an art school in neighboring Shinnecock Hills. It was proposed that the school would offer students the opportunity of painting directly from nature during the summer months, when most art schools in the cities closed down. The backing for this project was to be provided by Mrs. Hoyt and two prominent Southampton residents, Mrs. Henry Kirke Porter and Mr. Samuel L. Parrish. The plans included an "art village" (consisting of summer cottages for the students and a studio to be used for weekly criticisms, talks on art, and painting during inclement weather) and a summer house for Chase. Chase's house was to be situated close enough to the "art village" to ensure easy access, yet far enough away to guard the privacy he needed for his own painting.

Students from all parts of the country traveled to eastern Long Island to take part in this novel project, to paint the surrounding countryside. Why Shinnecock Hills? A contemporary writer explained: "To the usual observer it is nothing but sand dunes, wire grass, and scrub brushes, rolling monotonously to the water's edge. But the trained eye will see infinite variety in the lights and shadows of landscape bordered by the fickle sea and the ever-changing sky." [32, p. 340] One incredulous art student, however, had a more prosaic explanation: "The existence of the school there was primarily due to the fact that some rich people owned some poor land." [2,

p. 386] At first farmers and local residents were perplexed by the influx of art students wandering through the Shinnecock dunes in search of "painterly subjects." And, though not understanding the precipitous increase in the value of their land, they were reportedly willing to accept $250 for land previously valued at $2.50.

In any event, the school was a great success. Chase's house, designed by his friend Stanford White, was completed in 1892, the second year of the school's establishment. That summer, and each succeeding summer, the artist's family joined him at Shinnecock. Throughout the school's existence (1891–1902), regular attendence averaged a hundred eager pupils. The caliber of their work varied greatly, as did their artistic background and talent. They ranged from wealthy residents seeking diversion, to some of the country's most promising young artists, such as Joseph Stella, Charles Hawthorne, Edmund Greacen, Rockwell Kent, Lydia Field Emmet, Howard Chandler Christy, Arthur B. Frost, and the brothers Gifford and Reynolds Beal. The dedication and energy devoted by the more serious students to daily painting outdoors were a tribute to their teacher. Rockwell Kent, one of many who have recorded their enthusiasm during these years, later recalled: "No student at Shinnecock can ever have devoted himself to his work with greater energy. All of every morning and of every afternoon I would be out of doors, my easel set up in some field or grove or barnyard. All day I'd paint."[66] The Shinnecock art school served as a prototype for other summer schools in America, and the work created at Shinnecock during the twelve years it was in operation served as an exemplary American visual statement: simple, strong, unsentimental, and painted directly from nature.

The Bayberry Bush, painted about 1892, the year the Chase summer home was completed, depicts the artist's three daughters, Alice Dieudonnée, Koto Robertine, and Dorothy Bremmond, at play. They are almost overwhelmed by the lush bayberry bush, which is in effect the true subject of this study from nature (as indicated by the title). The children serve to enliven the composition and act as decorative notes of color. The eastern end of the Chase house can be seen on the horizon, across the long stretch of open dunes.

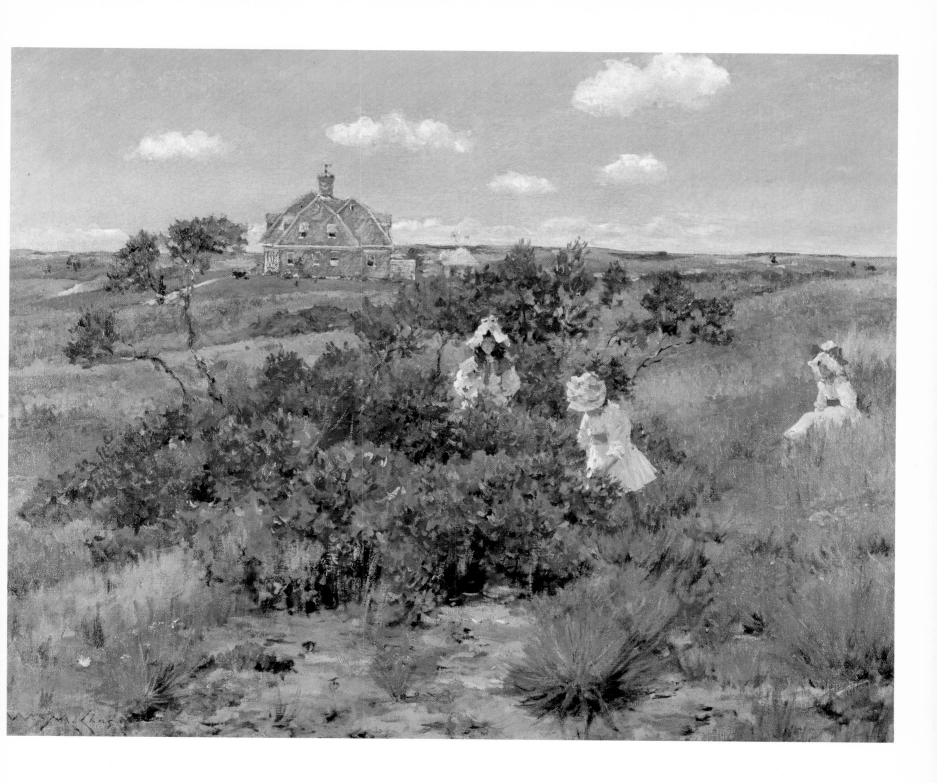

"Do not try to paint the grandiose thing. Paint the commonplace so that it will be distinguished." [42, p. 319]

In contrast to many nineteenth-century American landscape painters who devoted their time and creative efforts to searching out and recording the majestic beauty of this country's natural wonders (such as Niagara Falls and the Grand Canyon), Chase was satisfied in capturing the more elemental beauty of his everyday surroundings. In the 1880's he was attracted to the city parks of Brooklyn and New York; and in the 1890's he found suitable subject matter in the sandy dunes surrounding his summer house at Shinnecock Hills, Long Island. Although local residents could not understand the artist's interest in this desolate area, Chase realized its inherent beauty. A contemporary critic explained, "Prosaic eyes do not see these pictures, but prosaic eyes are only half open anyway." [43, p. 8] The many delightful scenes painted by Chase and his numerous pupils did much to open prosaic eyes to the resplendent beauty of the countryside surrounding Shinnecock Hills. In their compositions, Chase and his pupils managed to convert the commonplace into charming settings filled with the spirit of a summer holiday. The eastern end of Long Island soon became the summer mecca for artists and city dwellers alike.

Shinnecock Landscape was probably painted during the summer of 1892,[67] the second year of Chase's Shinnecock summer art school. Recalling a visit to the school that year, a contemporary writer later reported: "Except on rainy days, and they were so few last summer as scarcely to count, all of the work was done in the open air. . . ." [43, p. 12] Chase devoted two days

a week to the school and spent the rest of his time working on his own compositions and enjoying the company of his family, who had joined him for the summer at their recently completed seaside residence. The two days designated for teaching were Monday and Tuesday. On Monday mornings his pupils would bring their work of the previous week to the "art village" studio, where it was displayed for Chase's criticism. After this critique and an occasional lecture on art, the students would set up their easels in the nearby dunes and begin painting again, taking into consideration the comments made by Chase that morning. Chase would then make the rounds, visiting each pupil and offering friendly advice or witty criticism, depending on the immediate needs of the particular individual. On Tuesdays Chase would accompany his class to the neighboring countryside once again for a full day of painting in the open air.

Each student (approximately 100 every year) would usually complete one sketch in the morning and one in the afternoon, thus accumulating a considerable number of works for Chase to criticize. The untiring teacher, however, took great pleasure in this chore and treated these outings like a "picnic frolic." Both Chase and his pupils delighted in this summer painting, and their delight is conveyed in their joyous renditions of the Shinnecock Hills landscape.

Shinnecock Landscape, like Chase's painting *The Bayberry Bush,* depicts the artist's three daughters at play in the dunes, with the Chase home in the distance. The tranquil nature of this work reflects the artist's own serene attitude during these halcyon days under the warm sun of eastern Long Island. His recently completed summer house allowed him to combine his three favorite roles—father, artist, and teacher—at one place, Shinnecock Hills. His continuing delight is expressed in these radiant landscapes.

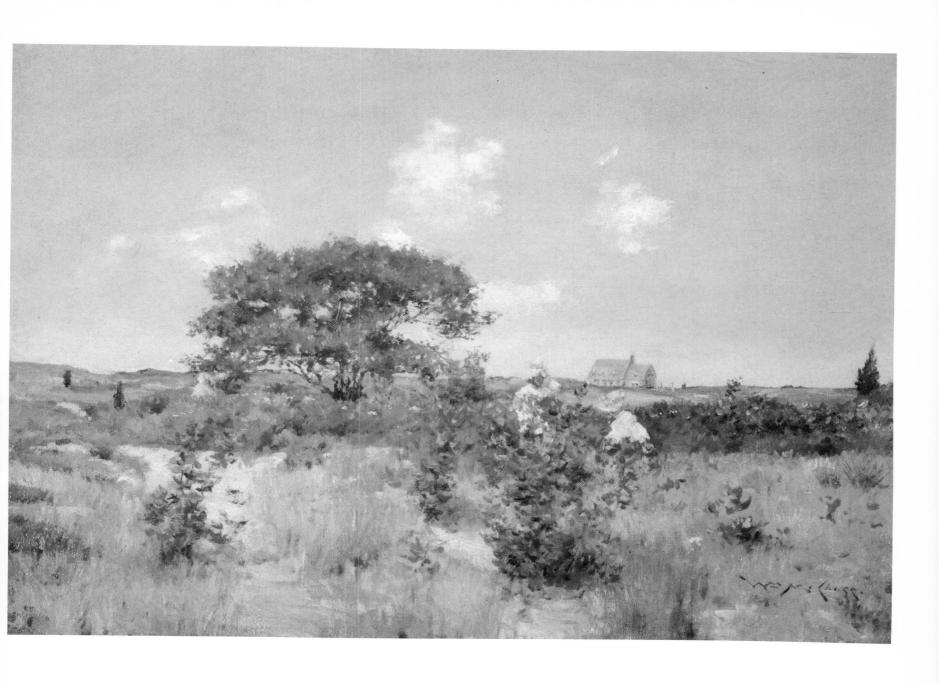

Plate 22
AT THE SEASIDE
Oil on Canvas
20" X 34" (50.8 cm X 86.36 cm)
Signed
c. 1892
The Metropolitan Museum of Art
(Bequest of Miss Adelaide Milton de Groot)

"Try to paint the sky as if we could see through it, and not as if it were a flat surface, or so hard that you could crack nuts against it. . . . In painting a sandy beach, try to imagine that you are walking upon it. . . ."[68]

Chase's advice to his students provides insight into his own art. As indicated in the above quotation, Chase was primarily concerned with naturalistic effects of light, atmospheric conditions, and particular textural qualities. He did not consider himself an Impressionist, nor did his pupils or contemporary critics describe him as such. One pupil, Howard Russell Butler observed: "Few painters weathered the shock of Impressionism as he did. It may have lifted his key or strengthened his color, but not to any notable extent. . . ."[69] Another Chase student, his early biographer Katherine Metcalf Roof, noted: "Chase has never chosen to paint with the deliberate mannerisms of the Impressionist. . . ." [42, p. 43]

The relationship of Chase's work to that of the French Impressionists is indirect. Like artists of this group, Chase drew inspiration from the work of Velázquez and Goya as well as the more contemporary Manet and Boudin. Chase was particularly impressed with the work of Eugène Boudin and owned at least seven of his paintings at one time or another. *At the Seaside* and several other beach scenes by Chase are undoubtedly indebted to the work of this French artist. The similarity of their subject matter, elegant figures decoratively arrayed on the seashore, is obvious, although in Chase's shore scenes, such as this one, there are generally fewer but more prominent figures. Stylistically, both artists render their subjects with a few well-placed, suggestive brushstrokes. Chase's application of paint is thinner than Boudin's, however, suggesting a more intense light and a crisp, clear quality of air. Commenting on the peculiarly American characteristics of Chase's landscapes, a contemporary critic remarked: "Perhaps more than any other, Chase was a representative American artist. In whose landscapes does one better get the tang and thinness and crispness of our air and the whitey [sic] brightness of our light?" [6, p. 537]

At the Seaside was painted on eastern Long Island, where Chase resided and taught an art class for several months each summer between 1891 and 1902. The works from this period of his artistic career are considered by many to be his finest, most mature statements. Although comparing any of Chase's work to that of his European contemporaries will yield obvious similarities as well as probable influences, it is equally important to recognize the differences, the original qualities arising from personality and milieu.

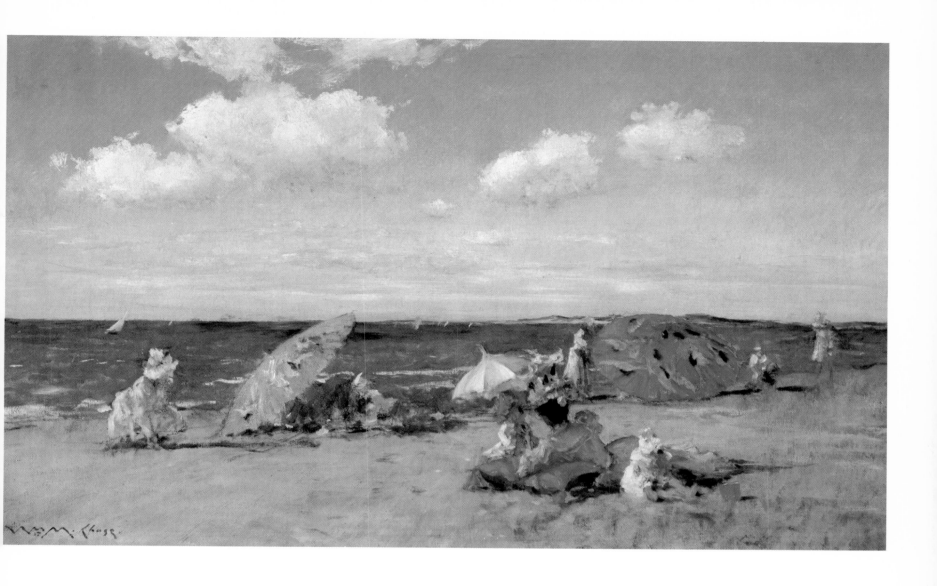

Plate 23
INTERIOR, YOUNG WOMAN AT A TABLE
Pastel
22" X 28" (55.9 cm X 71.1 cm)
Signed
c. 1892
Hirshhorn Museum and Sculpture Garden,
Smithsonian Institution, Washington, D.C.

"Paint, sketch in one atmosphere, but not in one monotonous color."
 [29, p. 433]

William Merritt Chase's concern with creating a quiet, harmonious, yet engaging setting is best expressed in his interior scenes, which depict the tranquil life of genteel America at the turn of the century. He expressed this mood in works such as *In the Studio* through use of consonant tonal gradations of color enlivened by an accent of a much brighter hue. In praising the effect of these interiors, Duncan Phillips wrote: "Whether it is the sumptuous splendor of a Venetian palace, shades from the summer sun, or just a perspective of rooms, in which one would like to live, the charm of a Chase interior is immediate. It is more than a trick of cool light on reflecting surfaces, mahogany table-tops and hard wood floors. It is the hint of once familiar moments long forgotten, a sentiment of the quiet dignity of a patrician home." [40, pp. 49–50]

In this instance, Chase has depicted his own rather patrician summer residence at Shinnecock Hills, Long Island. The setting is the artist's studio, with a view of the main hall in the distance, beyond the stairway. On the studio wall are a number of paintings and prints, including a reproduction of Henri Regnault's *Automedon and the Horses of Achilles* (Museum of Fine Arts, Boston) hanging just over the table. The overall warm, golden tonality of this Chase pastel is offset by the bright blue of an Oriental wall hanging in the upper left-hand corner of the composition, which serves to enliven the scene with its rich color. Although Chase generally included more foreground space to draw the viewer into his interior scenes, in this work the stairway and bright light visible in the distant room serve the same purpose.

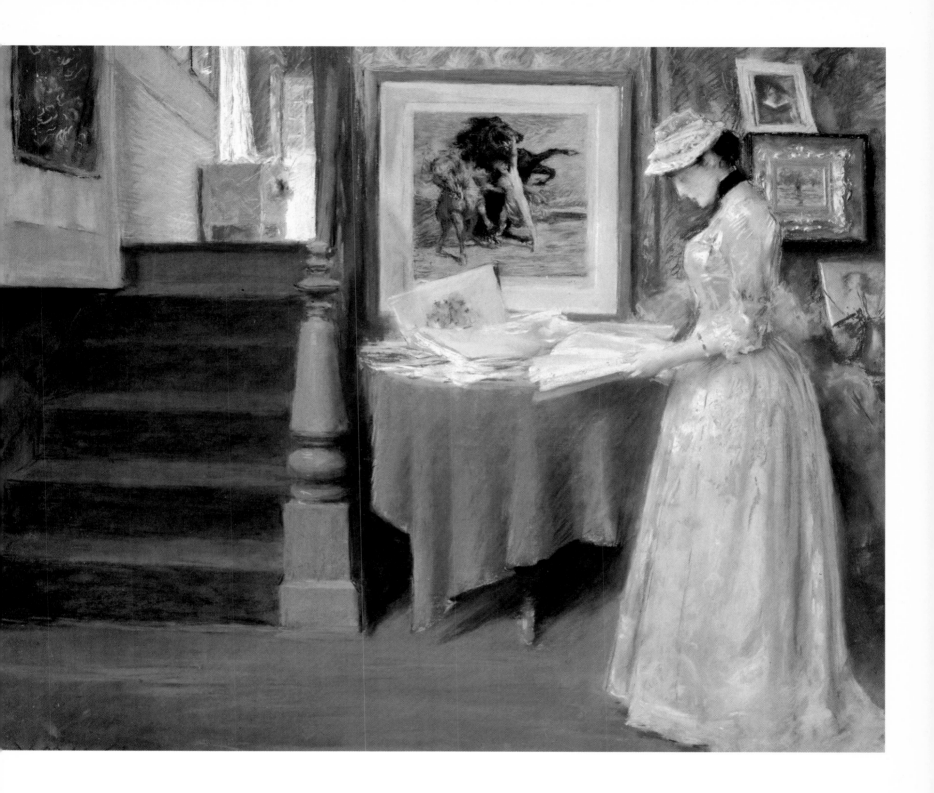

Plate 24
Plate 24
PORTRAIT OF MRS. C. (LADY WITH A WHITE SHAWL)
Oil on Canvas
75" X 52" (190.5 cm X 132.08 cm)
Signed
1893
The Pennsylvania Academy of the Fine Arts, Philadelphia

"As she arose gracefully and stood smiling before me I knew at once that fortune had sent me the very subject I had long hoped to find, a perfect type of American womanhood." [18]

The model here, who represented the standard of American beauty at the turn of the century, was Mrs. Clark, as described by Chase after their first meeting. Elsewhere he continued, "A clear-cut face with splendid profile— a steadfast expression of sweetness, loveliness, womanliness, and, above all else, dignity and simplicity, these two greatest elements of successful portraiture. She was dressed in a plain black gown, just as I should have wished. But just a touch was lacking? A white crepe shawl was hanging near, and I took it quickly and draped it about her shoulders. That was sufficient."[70] The result was his *Portrait of Mrs. C.* (better known as *Lady with a White Shawl*), which at the time of its completion Chase considered his greatest work.

According to Chase, Mrs. Clark was the original "Gibson girl." Aside from serving as a model for Charles Dana Gibson and Chase, she had also posed for Chase's friend J. Carroll Beckwith. Chase explained that his *Portrait of Mrs. C.* was not painted on commission nor for exhibition, but for the "love of the work purely." [40, p. 50] He praised the model for being congenial and for her keen appreciation of art. In this work he managed to personify all the attributes of American womanhood, as he believed only an American artist could, and later explained, ". . . I was very proud of having had the opportunity."[71]

Although he claimed he had not painted this work for exhibition, *Portrait of Mrs. C.* was widely exhibited in this country and was shown in major exhibitions in Paris (1899, 1900) and Berlin (1908). The painting was awarded a "place of honor" in the Exposition Universelle held in Paris in 1900, at which time it was described by a visiting art critic as follows: "Seen through the door from the room which contained the celebrated portraits by Sargent, it stood alone in the center of the wall, stately, dignified, aristocratic in pose, superb in reserved color . . . a delicious picture;

and all the foreign artists returned many times to gaze at it." [34, p. 97] In fact, wherever exhibited, it was praised for its monumental conception and vital characterization.

One of the earliest exhibitions in which it appeared was the annual exhibition of the Pennsylvania Academy of the Fine Arts in 1894. Shortly afterward, in 1895, it became the prized possession of that institution for a mere $500. Harrison Morris, managing director of the Academy, later referred to the amount paid for this masterwork as "a ridiculous sum." [34, p. 93] Chase benefited in other ways by this sale, however, and from the ensuing notoriety generated by this work. The success of this painting served to reintroduce him to the Philadelphia art scene (his first introduction having been in 1876, when his painting *Keying Up—The Court Jester* was exhibited at the Centennial Exhibition to critical acclaim). Even more important, *Portrait of Mrs. C.* served as his introduction to Philadelphia society and resulted in an appreciable number of commissions for the New York artist.

The year after this work was purchased by the Academy, Chase accepted a teaching position on its staff, traveling to Philadelphia once a week to teach classes during what was to be a long tenure, spanning the years 1896–1909. Harrison Morris later recalled these jubilant days: "He would talk delightfully as he wound about among the easels of the girls and young men, hanging an illustrative story on this canvas or imposing a criticism on that. . . . The class adored him, naturally. He was the soul of gentleness and kindness." [42, p. 307]

To accommodate his many portrait commissions, Chase opened a Philadelphia studio, similar in its elaborate furnishings to his former Tenth Street studio in New York. He also conducted a free class in a local public school for students who could not afford tuition at the Academy.

It is important to note that many critics and art historians have in the past mistakenly identified the model for *Portrait of Mrs. C.* as Mrs. Chase— an error undoubtedly born of its generalized title. The events surrounding the genesis of this painting, however, clearly identify the model as Mrs. Clark, who also served as Chase's model for several other paintings, including *The Opera Cloak* (Grand Rapids Art Museum, Grand Rapids, Michigan) an equally lovely if less imposing work.

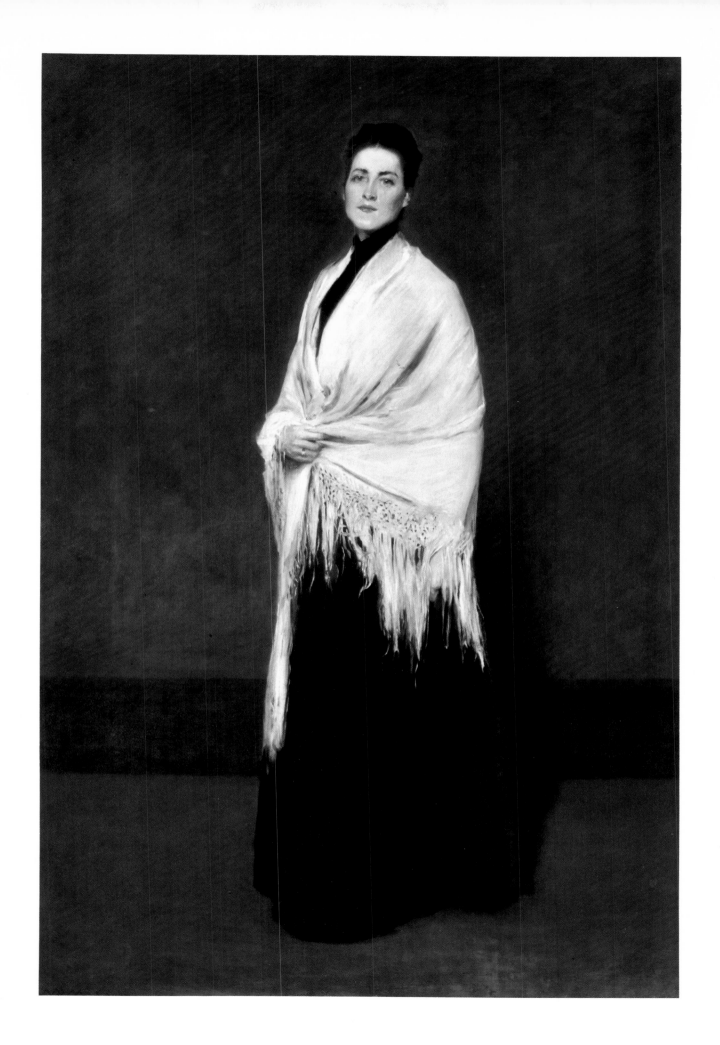

Plate 25
THE POTATO PATCH (GARDEN, SHINNECOCK)
Watercolor
11 3/4" X 15 3/4" (29.85 cm X 40.01 cm)
Signed
c. 1893
The Kennedy Galleries, Inc., New York

"Subject is not important. Anything can be made attractive. . . .
Aim to make an uninteresting subject so inviting and entertaining
by means of fine technique that people will be charmed at the way
you've done it." [29, pp. 433, 436]

Chase was versatile in his choice of both subject matter and medium. He painted everything from pots and pans to portraits and experimented with every conceivable medium. Whatever the subject or medium, his work was always interesting for his great flair and technical ability. Of all the various media he employed, however, watercolor was used least frequently. Only ten Chase watercolors can be documented reliably. And of these ten, one is known to have been destroyed, and only two others have been located.

The specific subject of *The Potato Patch* is somewhat unusual for Chase, who is better known for depictions of upper-class leisure rather than the daily chores of the working class. This painting does demonstrate dashing style and interest in color, however, as well as Chase's ability to render any subject in an attractive way. The composition of the work, with its broad foreground and dramatic diagonals rushing to the focal point of the picture, is also typical of Chase's landscapes and interior scenes.

Chase was a member of the American Watercolor Society and contributed to their annual exhibitions sporadically between 1879 and 1894. *The Potato Patch*, shown in 1894, was the last watercolor he exhibited with this group and was probably executed the previous year while at his Shinne-cock summer art school. It is unlikely, however, that Chase himself ever taught the art of watercolor painting. For his summer classes at Shinnecock Hills, he employed the well-known watercolorist Rhoda Holmes Nicholls to provide such instruction. Why Chase painted so few watercolors is unknown, although he did voice his general dissatisfaction with the way others handled the medium, complaining that "watercolorists often seem to discard all idea of values and naturalistic effect in using this medium." [42, p. 43]

Certainly, this was not true of Chase's own work, as can be seen in *The Potato Patch*. In this work he has made use of the special qualities of the medium (such as its delicate color and transparency) to render an atmospheric study painted directly from nature. His bold and forceful manner gives it both vitality and strength, traits often lacking in the work of lesser watercolorists of the period. Indeed, Chase shares with us the delight he found in experimenting with this medium. Acknowledging this fact, a contemporary critic noted: "The very materials with which Chase paints a picture are apparently a source of pleasure to him, and the gayety and ease with which he handles them are in a large measure communicated to his public." [23, p. xxix]

Among the few watercolors he executed, most were painted in the early 1880's, a time of great experimentation when he was also experimenting with pastels. The greater number of pastels he executed indicates that he found this medium better suited to his temperament and artistic needs. With pastels he could achieve more intense color that would not lose its vibrancy with time. Whatever the reasons, it is disappointing that he did not complete more watercolors, since the few that exist demonstrate his proficiency in this medium.

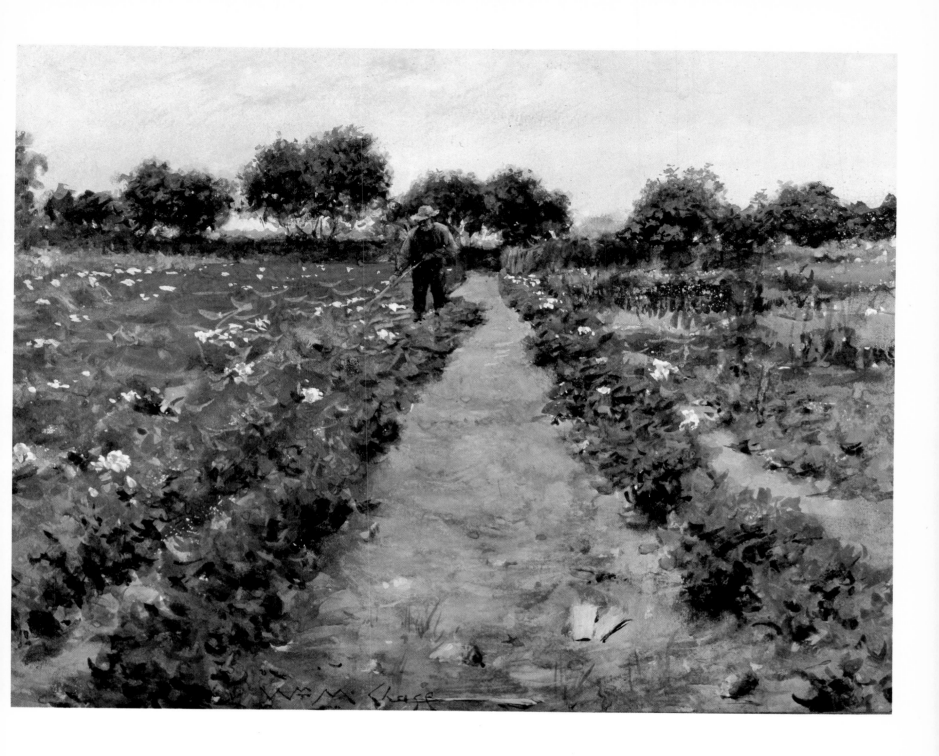

"Great artists get so much done because they delight in their work. Van Dyck died at thirty-five, yet left enough for six artists to have done. Rubens also was a marvel in this respect." [29, p. 436]

This statement was undoubtedly intended by Chase as a means of defending himself from adverse criticism of his own prolific nature. Chase probably completed more works of art than any of his American contemporaries. Many of his portrait sketches and still-life demonstrations were completed in merely an hour or two. More "finished" works, like *A Friendly Call*, were completed in several days. This does not mean, however, that Chase was undiscerning with regard to quality. He advised his pupils, "Keep a high ideal. You will get less done, but it will be better." [29, p. 436] And he claimed that for every one of his own works he signed, he destroyed ten that did not reach his high standard. Considering Chase's ego and the prodigious number of works he did sign, this statement is likely somewhat of an exaggeration.

When criticized for the apparent ease and obvious speed of his portrait painting, Chase countered with an amusing anecdote: "A famous English surgeon was called in to perform an operation on a very rich nobleman. It happened that one stroke of the knife was all that was needed. His fee was 1,000 guineas. The nobleman paid with protest. 'You were not one minute doing it,' he complained. 'That's true,' replied the surgeon. 'I earned that fee very easily. Suppose the next time you do it yourself.'"[72]

A Friendly Call is among Chase's most popular and best-known works. When first exhibited at the Society of American Artists' annual exhibition of 1895, it was awarded the Shaw Fund prize, at which time one critic noted, "Though Mr. Chase has painted subjects quite similar before, it must be admitted that this time he has been unusually successful."[73] A second critic, disagreeing with this appraisal, objected to the minor role played by the figures in this composition: "They count for almost less than the embroidered cushions and the tall mirror...."[74] Actually this was, to some extent, the artist's intention—an "ensemble" in which the figures compliment rather than dominate the setting. In fact, the subject of *A Friendly Call* is the event itself, a tête-à-tête between Mrs. Chase (on the right) and a female visitor. The painting was not intended to be a figure study but rather an interior, or a "conversation piece," a sort of secular *sacra conversazione* in which the setting is as important as the figures.

The setting of this painting is Chase's studio adjoining his summer home at Shinnecock Hills, Long Island. In this scene he presents the quiet dignity of his home, the home of a gentleman artist with refined taste, elegantly displayed and gracefully conveyed through his art.

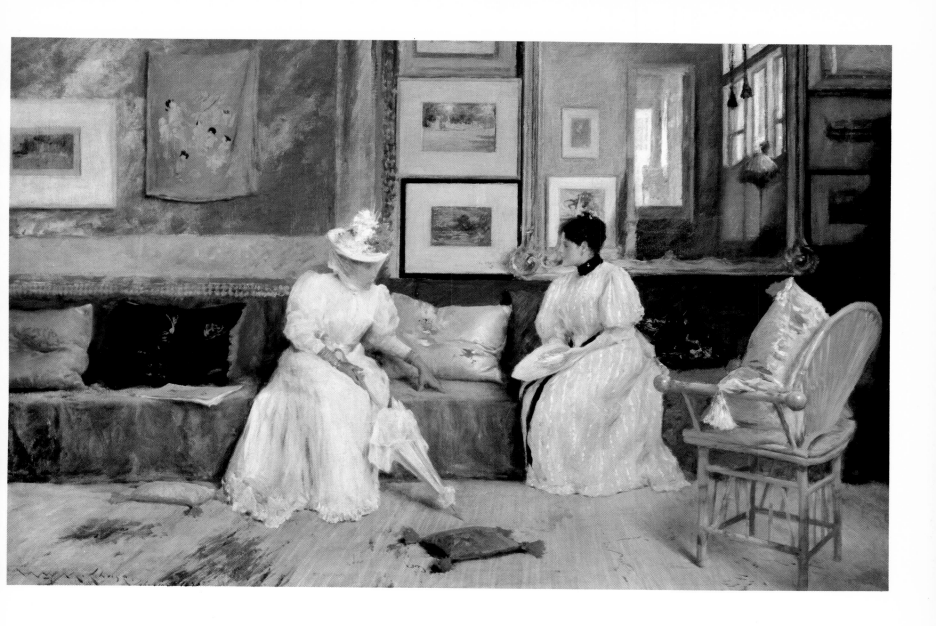

Plate 27
THE GOLDEN LADY
Oil on Canvas
40 5/8" X 32 3/4" (103.19 cm X 83.19 cm)
Signed and inscribed: "Madrid, 1896"
1896
Parrish Art Museum, Southampton, New York (Littlejohn Collection)

"I am going to establish at Madrid a school of painting—an American school. Such a venture would have been laughed at a comparatively short time ago. Today, however, I have not only assurances of plenty of American pupils, but pupils are also coming in numbers from Paris, and Munich, the greatest art centers today in Europe. Our school at Madrid is to be like the school at Athens, and I have not the slightest doubt of its success."[75]

This highly confident statement was made by Chase shortly after the disastrous auction of the contents of his famous Tenth Street studio in January, 1896. Despite generous presale publicity, the gross receipts amounted to barely $21,000, a fraction of the true value. Commenting on Chase's personal misfortune, one critic lamented: "Altogether it was a sad affair, and made one heartily ashamed of our so-called patrons of American art who, by their lack of appreciation of the productions of one of the best painters on the continent, make such a result possible. Mr. Chase has long been recognized as the head of the profession. Contrast the beggarly recognition accorded him 'outside' of the profession with the splendid treatment of men occupying a similar position in London, Paris or Berlin. Is it surprising that he has resolved to shake from his feet the dust of his ungrateful country, and join the distinguished contingent of the expatriated across the Atlantic?"[76]

It is unlikely that Chase seriously considered such a drastic move for long, if ever. More likely, such a statement was made to underline his own self-confidence and draw further attention to his teaching, from which he gained his main financial support. Shortly after this auction, he did leave for Spain, accompanied by his wife, his daughters Alice and Dorothy, and a group of students. The trip was, according to Chase's first biographer Katherine Roof, "a very happy one for all concerned." [42, p. 168] His plans for establishing an art school in Madrid were never consummated; instead, the contingent returned home in June of that year, so that Chase could conduct his annual summer class at Shinnecock Hills.

During this trip to Spain in 1896, both Chase and his pupils took advantage of the treasures of the Prado and copied the masterworks of Velázquez, whom Chase considered to be the greatest painter of all time. According to one of the many amusing anecdotes related by Katherine Roof, it was at this time that several Spanish artists observed Chase copying Velázquez's *Las Meninas* and exclaimed "Velázquez lives again!" [42, p. 169]

The Golden Lady was painted during this revitalizing trip to Spain. Never one to be disturbed for long by personal setbacks and always confident in his artistic ability, Chase soon regained his usual exuberance and sunny nature. This sensitive portrayal, undoubtedly of one of his pupils attending the Spanish class, is one of the artist's finest portraits of the 1890's. Holding a sketchbook and a red pencil, the young student is momentarily distracted from her own work to pose for her master. Her sympathetic expression reflects the admiration and respect she has for her teacher, a respect shared by her fellow pupils. Although Chase may not have enjoyed and benefited by the full appreciation of contemporary art patrons, he was more than compensated by the dedication and constant support of his many pupils. In expressing the personal nature of his relationship with them, Chase once commented, "I believe I am the father of more art children than any other living man, and they are a well-behaved lot—really. It is one of my consolations in life that wherever I go I see my children, and some of them really care to see me. . . . It is because I am keenly in sympathy with every effort they make." [16, p. 113] *The Golden Lady* glowingly reflects this bond of warm friendship and understanding.

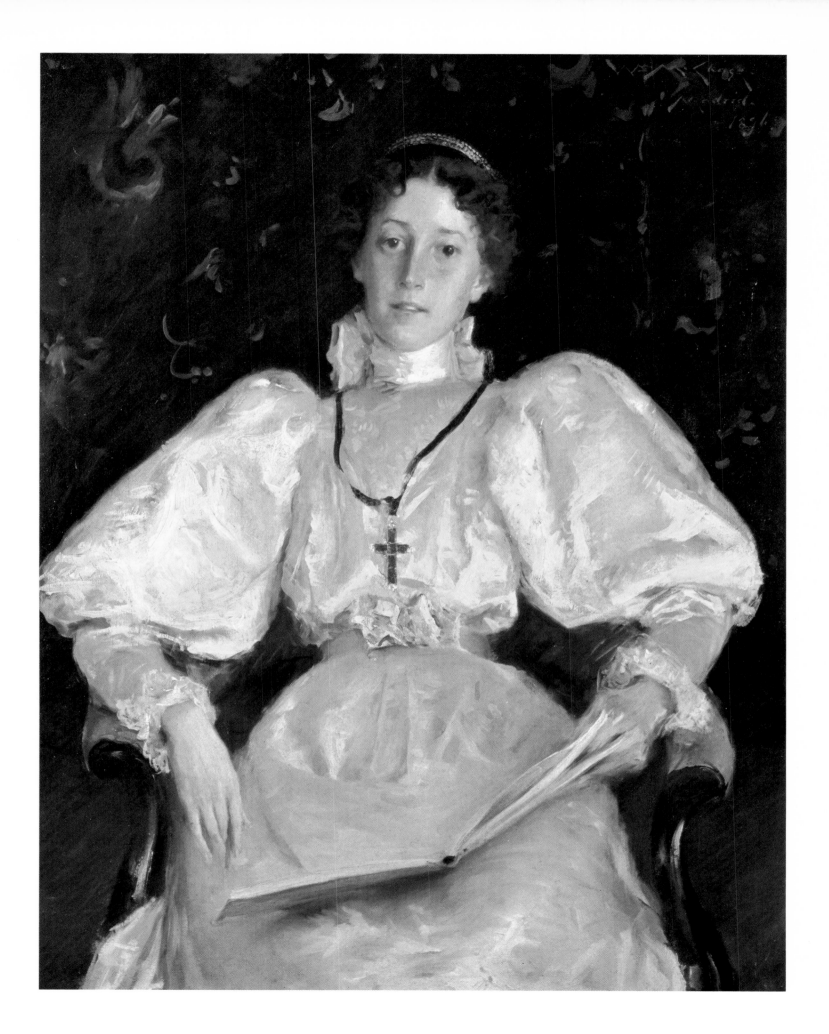

"The successful picture ought to look as if it has been blown on the canvas with one puff." [42, p. 321]

One of Chase's most charming paintings, *Did You Speak to Me?* is a delicate, thinly painted sketch of the artist's daughter Alice Dieudonnée. Her pose and her direct inquiring gaze capture a fleeting moment, similar to a candid photograph. Although there are a few family photographs that relate to Chase's painting, their relationship is indirect, and it is unlikely that Chase referred to photographs in composing his paintings. Like the Impressionists, however, Chase realized the engaging immediacy of an impression of a transient moment, such as he has captured in this painting.

In this work, Chase has focused on the action or gesture of his daughter as she turns to address her question to the viewer. She is pivotal in the composition and activates the scene with her very motion. The visual impact is as simple and direct as her question—the title of the work. In his clever manner, Chase has created a situation in which a response seems expected of the viewer, thus engaging his attention.

Although often criticized for the sketchy "unfinished" look of his work, Chase has managed to go a step further in this particular painting by including in the background an unfinished painting propped against another work, almost as if intending a visual pun or good-natured jibe at his critics.

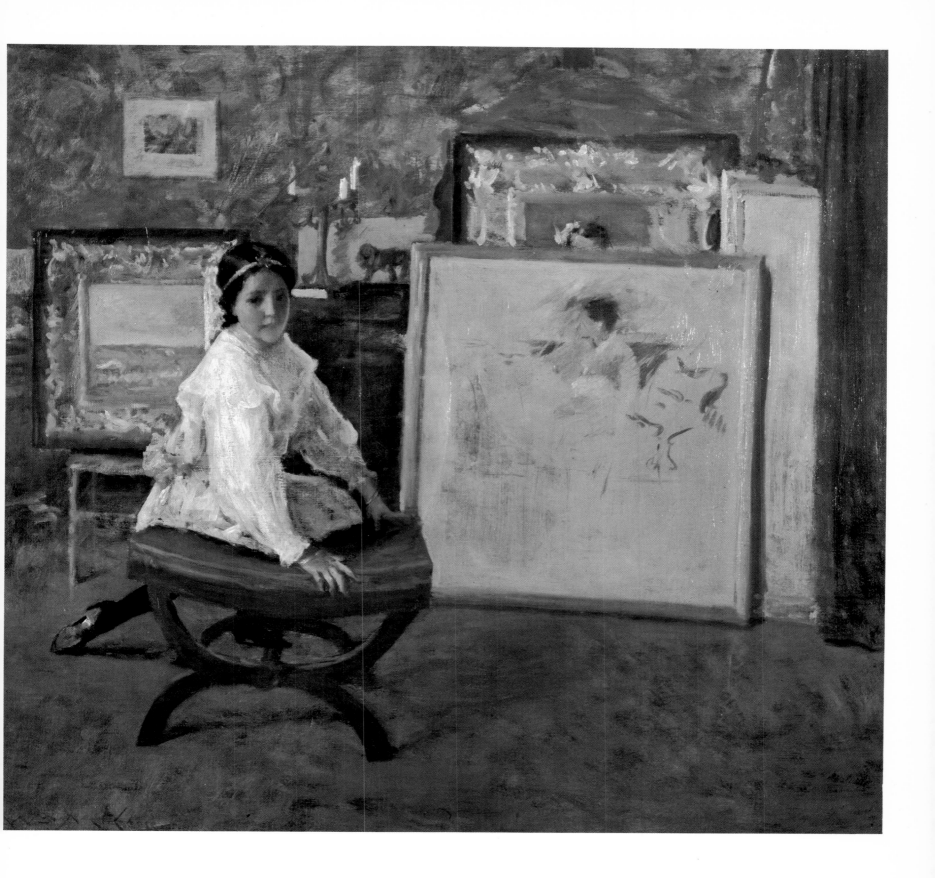

Plate 29
Plate 29
FOR THE LITTLE ONE (HALL AT SHINNECOCK)
Oil on Canvas
40 1/8" X 35" (101.92 cm X 88.9 cm)
Signed
c.1896
The Metropolitan Museum of Art (Lazarus Fund, 1913)

"The harshest criticism—the very harshest—is when you hear it said 'What a lot of time it took him to do that!' The successful work is not of that kind—it looks as if it had been blown upon the canvas and entirely without effort." [16, p. 113]

Even before Chase was aware of the work of the French Impressionists, he realized from his Munich training the value of the oil sketch. He seldom did preparatory drawings of any sort but, instead, drew with his brush. He instructed his students to do likewise: "We all see color and form. Why not begin with color at once, and work with a brush loaded with paint rather than with black and white?" [33, pp. 135–136] In his first important one-man exhibition, held at the Boston Art Club in 1886, Chase included "sketches" and "studies," titled as such in the exhibition catalog. Although this exhibition was generally praised by the critics, one complained, "The only argument brought against Mr. Chase is that he does not sufficiently 'carry out' his pictures." [4] Chase, on the other hand, felt that most artists don't know when to stop painting and, in overworking their paintings, sacrifice a sense of freshness and spontaneity. In one of his witticisms he stated, "It takes two to paint a picture, one to do the painting and the other to stand by with an axe to stop it at the right moment." [7]

For the Little One, painted about 1896, displays Chase's enduring interest in the "sketch." Although this is obviously a finished and accomplished work, elements such as the bentwood chair in the background are merely suggested in a few sketchy strokes. Like the French Impressionists, Chase was aware of the value of the camera. And although it is unlikely that he actually resorted to photographs in composing his works (as did such other American artists as Eakins and Robinson), he did make use of the principles of photography. For example, he advised his students, "You can have only one focus in a picture—be like a camera, and as you focus one spot, the others lose in distinctiveness [sic]. You can not have everything on one plane, something has got to be lost, so select one focus and paint accordingly." [33, p. 138]

In the painting *For the Little One*, Chase clearly focuses on the subject, Mrs. Chase sewing. The other objects in the composition are dissolved in the strong summer light streaming through the window. The broad expanse of foreground and daring diagonals of the composition are technical devices often used by the artist in his interiors and landscapes, to create space and suggest depth. The setting for this particular painting is the main entrance hall of the artist's summer home. Mrs. Chase is seated at the back of the large room, taking advantage of the north light for her sewing. Like Chase's other interiors, this work depicts the uncomplicated, leisurely life of American gentry at the turn of the century. He manages to create in such works a simple elegance and refinement and to capture the generally carefree attitude of this period in America. The pastel colors of this work, as well as the light touch, are directly related to Chase's work in pastel during the 1880's. It is interesting to note that when *For the Little One* was exhibited at the Society of American Artists in 1897, the American critic Sadakichi Hartman praised it as revealing "subtleties that are on a par with Degas,"[77] the French master of pastel.

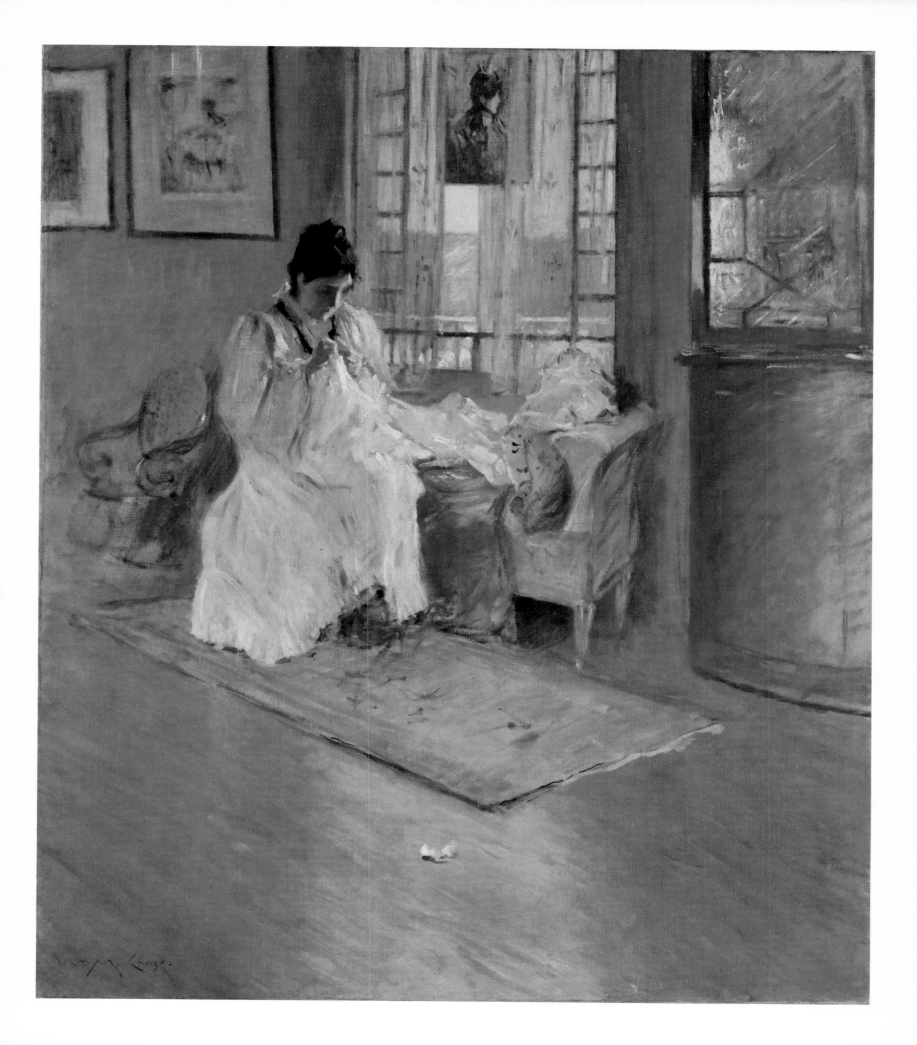

"We are a new people in a new country. Watch the crowds along the Piccadilly or the Champs Elysees—you spot the Americans among them almost as easily as if they wore our flag in their buttonholes. It means that already a new type has appeared, the offspring as we know of European stock, but which no longer resembles it. . . . And just as his look and character are different, so his art must be different." [14, p. 442]

Chase was very aware of this "new type," this American "breed" with its distinct spirit and character; and he portrayed his countrymen as he saw them, with the same vital energy that motivated them and distinguished them from the rest of the world. He painted in an American style, an eclectic style, which, like the people he painted, had a Euroepan heritage but had evolved to a stage where its American spirit was immediately recognizable. Commenting on this development, a contemporary critic wrote: "The national style, so far as there can be any American style, is a composite, blending indistinguishably the influence of old and new schools of painting. In a certain sense Mr. Chase is a typical American artist." [23, p. XXIX]

Chase was a clever artist and an expert technician who could, and did, borrow from everyone—from the Old Masters right down to his own pupils. He believed that no artist could be "original" in the true sense of the word, that all artists are influenced by the art of others to some degree. He redefined "originality" in art terms: "Originality is found in the greatest composite which you can bring together." [16, p. 116] All of his life he kept an open mind, learning from the improvements and mistakes of others. He advised his own students, "Be in an absorbent frame of mind. Take the best from everything." [29, p. 434] Chase himself went one step further: taking the best from the best, he achieved in his mature statement the apotheosis of nineteenth-century eclecticism in American painting.

Many critics of the period commented on the distinctly American character of Chase's art. One described it as "sane, unsentimental, truthful and unpretentious. . . . typical American traits." [23, XXIX] Chase himself believed that artists were at their best when painting their own countrymen. A contemporary writer explained, "He has laid down this rule, not in a chauvinistic spirit, but because he feels that an artist of one nation, or rather race, cannot make a true likeness of a man or woman of another—unless he be a Van Dyke or a Sargent."[78] This "rule" was probably based on the fact that many of America's affluent citizens were traveling abroad at this time to have their portraits painted by European artists.

The Blue Kimono, though not a portrait in the true sense of the word, is a fine example of Chase's ability to combine the influences of several sources and yet come up with his own distinctly American statement. The Japanese costume and accouterments were by this time being used by many artists in their work, although Whistler is the most likely source of Chase's inspiration. The thinly painted surface and decorative composition are also Whistlerian. The setting and the attitude of the sitter might also suggest Alfred Stevens, and the elegance of her elongated hands may owe something to the refined statement of Sargent; but the bold presence of the sitter's character is pure Chase. The model is clearly an American, with a sharp, intent expression. She is bold, direct, and spirited, quite unlike Whistler's beautiful but often frail creatures. The work is expressively truthful, unlike Stevens' sentimental renditions, and is not overly refined, like some of Sargent's work. It is simple and decorative, yet strong. In terms of the variety of textural elements alone, it is a tour de force.

Owing to Chase's eclectic nature and close ties with the important artists of Europe, the American qualities of his art have often been obscured and overlooked in recent years, so that the importance of his own creative statement has been neglected. This was not so during his lifetime, as was pointed out by contemporary critics. His students were also aware of the typically American character of his work and his service to American art in general. One wrote, "Mr. Chase has accomplished a wonderful work for the good of art, both nationally and internationally. His honest, straightforward, vigorous American spirit is truly reflected in the sincerity of his art, and what a great legacy has he left the art world . . . Ah! the living inspiration he has left. America may well be proud of this great man. America is." [33, p. 129]

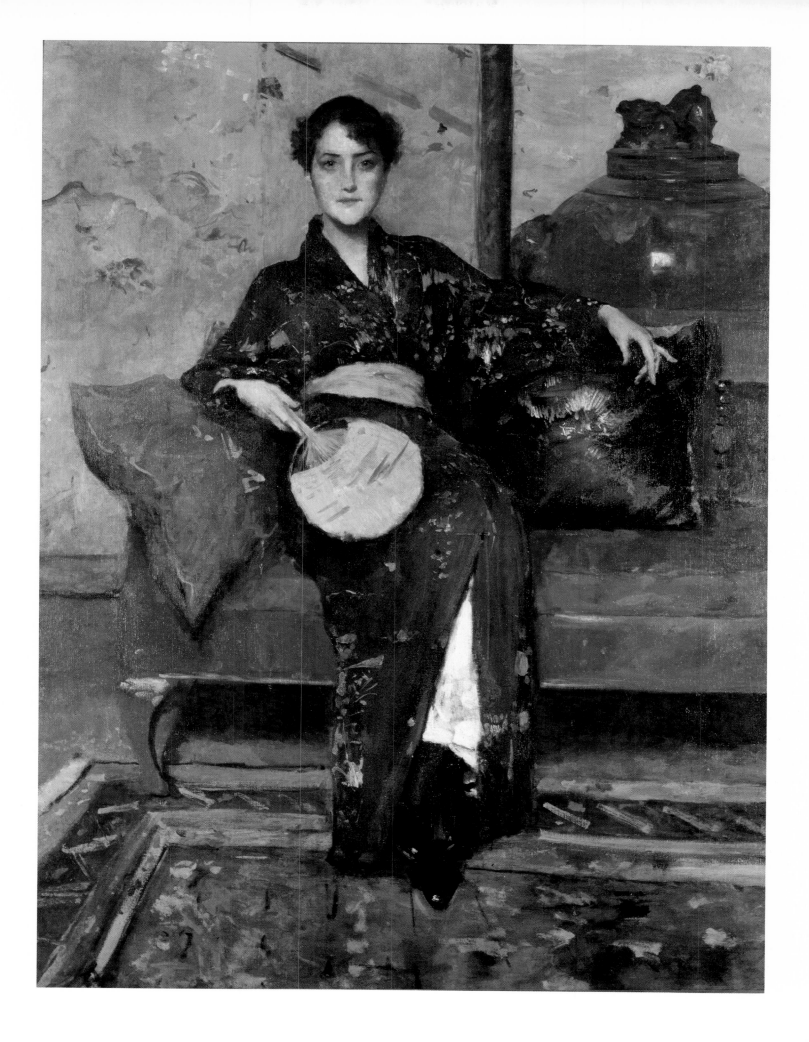

MY DAUGHTER DIEUDONNEE (ALICE DIEUDONNEE CHASE)
Oil on Canvas
72 3/4" X 36 1/2" (184.785 cm X 92.71 cm)
Signed
c. 1902
Parrish Art Museum, Southampton, New York (Littlejohn Collection)

*"It may truthfully be said that artists probably get more pleasure
out of portrait painting than almost any other kind of art work."* [36]

Although Chase was a versatile artist, equally adept at landscapes and still-life paintings, he painted more portraits than any other single theme. Of these portraits, only a small percentage were commissioned works; the others might better be described as figure studies, since the people represented served merely as models for the artist's compositions. Aside from professional models, Chase made use of his wife Alice and their eight children; and of the children, the one most often chosen to pose was his daughter Alice Dieudonnée. She posed from when she was an infant until after she was married and had her own children. Chase's many paintings of her give a pictorial account of her growing beauty.

My Daughter Dieudonnée, painted about 1902, depicts her at about age fifteen. The first of Chase's children, she was born in 1887, one year after the artist married Alice Gerson Chase. In an unidentified contemporary news clipping she was described as "a charming young woman, typically American, and characterized by an alert mentality tempered by gracious womanliness. From her father she inherits her marked artistic ability, while her literary skill is an inheritance from her mother's people."[79] In the same account, she is referred to as a skillful amateur actress," and her effects in costuming and posing are worthy of a professional."

Certainly there was no artist who was better at consistently capturing the carefree elegance so prevalent in America at the the turn of the century. Both in his life-style and in his art, Chase represented all that was considered high fashion and cultivated taste. In *My Daughter Dieudonnée*, Chase captured the apotheosis of high style and refined taste at the beginning of the twentieth century. Dressed in her summer finery and lounging in a wicker chair, Dieudonnée reflects the transitory elegance of a bygone era.

This painting was pouplar during Chase's lifetime and was widely exhibited both in this country and abroad, where it was shown at the International Exhibition held at the Crystal Palace in Munich in 1905.[80] When it was exhibited at the Albright Art Gallery in Buffalo in 1909, it was praised by one critic for its "charming simplicity and reserve."[81] Prized for its casual elegance and charm, it was also featured in the German periodical *Kunst und Kunst Handwerk* in 1903.[82]

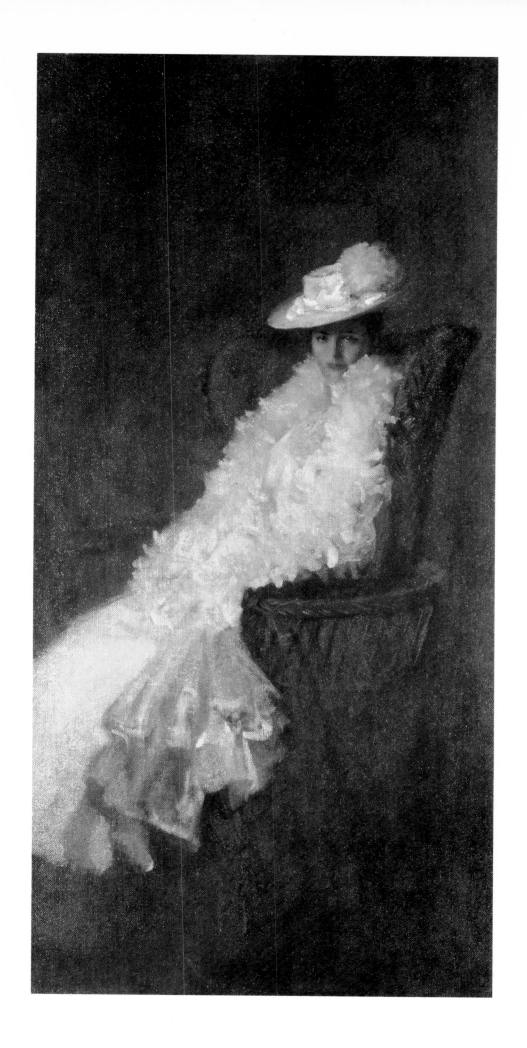

"I enjoy painting fishes: in the infinite variety of these creatures, the subtle and exquisitely colored tones of the flesh, fresh from the water, the way their surfaces reflect the light, I take the greatest pleasure. . . . It may be that I will be remembered as a painter of fish. . . ."
[25, pp. 198–199]

Near the end of his distinguished career as an artist, in 1913, and with his usual alacrity, Chase concluded that he might indeed be best remembered as a painter of fish. After all, his still-life paintings of fish were highly prized—sought after by major museums and discussed at great length by art critics—for they represented the apotheosis of technique. In his own estimation, these works were paintings of great artistic beauty, no less so than his paintings of beautiful women. In complimenting his wife on a sequined gown she was wearing one evening, Chase compared its radiance to the sheen of fish scales—a compliment that only an artist's wife, or perhaps only Alice Chase, could appreciate.

His celebrity as a painter of fish began in 1904 when Chase painted *An English Cod*, purchased by the Corcoran Gallery of Art in Washington, D.C., shortly after it was completed. According to the artist, this monumental still life was completed in just over two hours. He claimed he had rented the subject from an English fishmonger and was able to return the fish while it was still fresh enough to be sold—an impressive feat, not to mention a delightful story. Equally impressive was the work itself, a technical tour de force. The critics were overwhelmed by its power, and the public was charmed by the accompanying story. The resultant publicity generated an immediate demand for additional works of this kind. Chase, only too happy to oblige the market, explained that an artist should not seek out the distinguished theme to paint, but should "paint the commonplace in such a way as to make it distinguished." [25, p. 197]

Still Life: Fish, like *An English Cod*, was painted abroad, but some years later, in 1912 in Bruges, where Chase was teaching one of his then famous European art classes. The following year it was purchased by the Brooklyn Museum. Fortunately, W. H. Fox, a writer for the *Brooklyn Museum Quarterly* who happened to be in Bruges to witness the actual execution of the work later described the process: "The canvas had been prepared with a surface of silvery white and blue tones somewhat resembling the prevailing color of the fish. Over this the painter put in a background of a reddish-green tone. A small spot of brilliant white shone on one of the fish. Mr. Chase had put on the canvas the highest light and then rubbed the darkest tone into the picture. 'Between these two tones,' he said, 'is my gamut'. . . . For four hours a group of spectators, most of them Mr. Chase's pupils, watched him working at the subject with concentration of mind and feverish energy. There was little conversation during the period. The atmosphere of the studio was fraught with nervous interest and enthusiasm. . . . When he threw down his brushes at noon, the picture was so far advanced that it might very properly have been exhibited." [25, p. 198]

The painter was sixty-three years old when he completed *Still Life: Fish*, yet his energy and facility were astonishing. He was a great showman, who enjoyed the act of painting as much as the finished work of art. And his remarkable enthusiasm and excitement show in this painting.

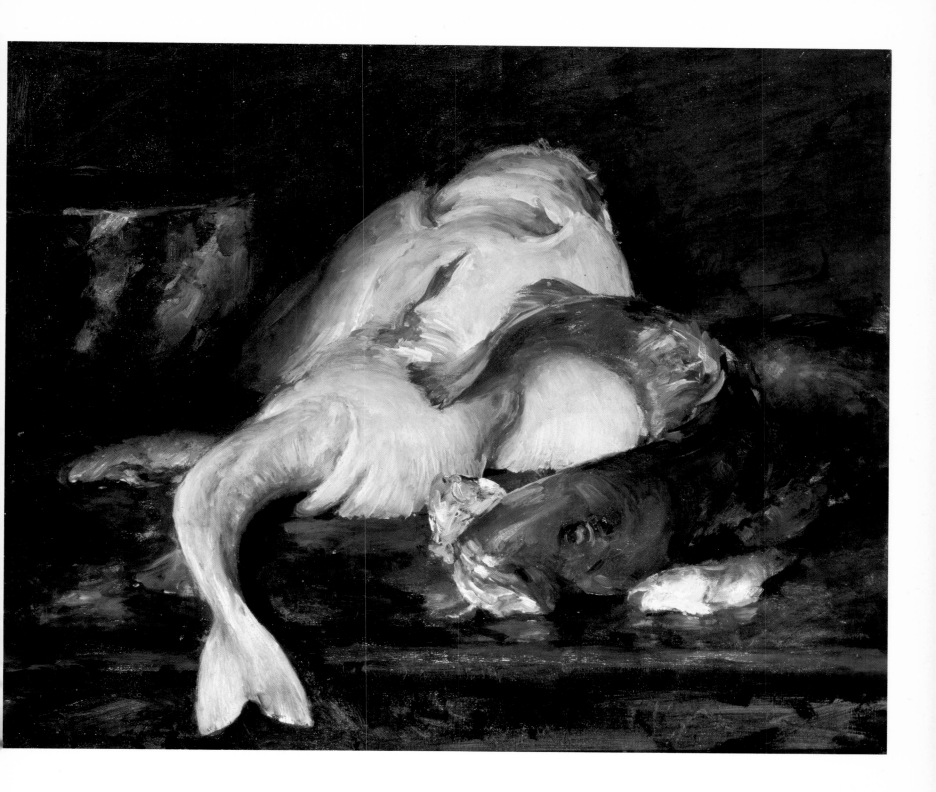

Notes

[1]Anonymous, "The Chase Exhibition," *The Outlook* (January 29, 1910), p. 230.

[2]Early biographical information provided by Indiana Historical Society LIbrary, letter from Tom Rumer to Doreen Bolger Burke (November 8, 1976; courtesy of Burke, Assistant Curator, Metropolitan Museum of Art, New York.

[3]For a thorough discussion of Chase's pre-Munich years, see the catalogue *Chase Centennial Exhibition* [10].

[4]Anonymous, "An Artist's Collection," *The Collector* (vol. 2, 1892), p. 32; courtesy of Bruce Weber.

[5]Georgia O'Keeffe, letter to author (August 18, 1972).

[6]F. Usher De Voll, "Student Notes and Reminiscences," manuscript printed in A. Milgrome, "The Art of William Merritt Chase," doctoral dissertation (University of Pittsburgh, 1969), p. 125. [33].

[7]Jerome Meyers, *Artists in Manhattan* (New York, [c. 1940]), *p. 38.*

[8]Anonymous, "Art Notes on William Merritt Chase," manuscript printed in A. Milgrome, "The Art of William Merritt Chase," doctoral dissertation (University of Pittsburgh, 1969), p. 140. [33]

[9]Ibid.

[10]For a full discussion of Chase's Shinnecock summer art school of, see Pisano [44].

[11]*Art Amateur* (February, 1896), p. 56.

[12]*Ibid.*

[13]Archives of American Art, New York, microfilm (NTM4, frame 588), unidentified clipping.

[14] Unidentified news clipping (Boston Transcript); October 15, 1913 [no page]), artists' clipping file, New York Public Library.

[15]Exhibited at Salmagundi Club's "Black and White Art Exhibition" of that year as *Monotype* (catalog no. 491).

[16]Only one monotype by Chase with any color is known to exist, and that is a landscape formerly owned by the Kennedy Galleries, New York.

[17]Annie Traquair Lang, letter to Estelle Manon Armstrong (November 3, 1916); Estelle Manon Armstrong album, courtesy of Mr. Joseph J. Roberto.

[18]*Ibid.*

[19]*Ibid.*

[20]De Voll, Milgrome dissertation, p. 129. [33]

[21]Anonymous, "The First Annual Exhibition of the Society of American Artists," *New York Times* (March 7, 1878), p. 4.

[22]The others are *Whistling Boy* (Detroit Institute of Arts) and another work titled *The Apprentice* or (*Boy Eating an Apple*; private collection).

[23]The model in all these works is recognizably left-handed.

[24]Anonymous, "Present Tendencies in Art," *Harper's New Monthly Magazine* (March, 1879), p. 494.

[25]*Art Amateur* (April, 1887), p. 100.

[26]Anonymous, "William M. Chase—Painter," *The Art World* (December, 1916), p. 156.

[27]Anonymous, "An Artist's Collection," *The Collector* (vol. 2, 1892), p. 32.

[28]K. M. Roof, "William M. Chase: The Man and the Artist," *Century Magazine* (April, 1917), p. 834.

[29]W. C. Brownell, "American Pictures at the Salon," *Magazine of Art* (vol. VI, 1883), p. 494.

[30]Fr. Pecht, "A German Critic on American Art," *Art Amateur* (September, 1884), p. 78.

[31]*Ibid.*

[32]For another interpretation of this emblem and further discussion on the *Portrait of Miss Dora Wheeler*, see Marling. [30, p. 47]

[33]*Ibid.*, p. 49.

[34]*Ibid.* The setting is identified by Marling.

[35]Another large tempera painting was exhibited by Chase, in this show: *A Madrid Dancing Girl* (Montclair Art Museum).

[36]Clipping, *New York Commercial* (believed to be dated 1886), artists' clipping file, New York Public Library.

[37]M. G. Van Rensselaer, "Pictures of the Season in New York, II," *American Architect and Building News* (February 27, 1886), pp. 103–104; from a partial transcript of this article, courtesy of Lois Dinnerstein.

[38]*Art Amateur* (April, 1887), p. 98.

[39]The known exhibitions for this society were held March 17–29, 1884 (W. P. Moore Gallery); May, 1888 (Wunderlich Gallery); April, 1889 (278 Fifth Avenue); and May 1–24, 1890 (Wunderlich Gallery).

[40]*Art Amateur* (April, 1884), p. 103

[41]*Art Amateur* (January, 1883), p. 29.

[42]*Art Amateur* (May, 1885), p. 121.

[43]*Art Review* (February, 1887), p. 20.

[44]*Art Amateur* (April, 1887), p. 100.

[45]In this instance, Whistler's portrait of the violinist-composer Pablo de Sarasate was likely Chase's direct source of inspiration.

[46]*Winter*, oil on canvas, 4" x 5½", signed lower right: "De Nittis." Chase sale: March 7–8, 1912 (no. 3).

[47]Indicated on Chase survey form issued by The Parrish Art Museum and filled out by the Phoenix Art Museum; courtesy of Chase Archives, The Parrish Art Museum, Southampton, N.Y.

[48]*Art Amateur* (February, 1894), p. 77.

[49]Clipping, *Daily Graphic*, New York (February 17, 1887), artists' clipping file, New York Public Library.

[50]*Ibid.*

[51]*Art Amateur* (July, 1886), p. 25.

[52]Elizabeth Barlow, *Frederick Law Olmstead's New York* (New York, 1972).

[53]J. Carroll Beckwith, letter to William M. Chase (July 28, 1916); collection of the author.

[54]Dianne Pilgrim, *American Impressionist and Realist Paintings and Drawings from the Collection of Mr. and Mrs. Raymond J. Horowitz* (exhibition catalog), Metropolitan Museum of Art, 1973, p. 28 (quotes Clarence Cook's review of the Society of Painters in Pastel exhibition of 1888.)

[55]*Art Amateur* (June, 1889), p. 4.

[56]*Art Amateur* (May, 1895), p. 150.

[57]*Art Amateur* (February, 1896), p. 64.

[58] Clipping, W. M. Chase, "How I Painted my Greatest Picture," (unidentified article), artists' clipping file, Corcoran Gallery of Art, Washington, D.C.

[59]H. R. Butler, "Chase the Artist," *Scribner's Magazine* (February, 1917), p. 257.

[60]Carmencita was born as Carmen Dauset (or Dausset) in 1868 in Almería, Spain. Her first stage appearance was at the Cervantes Theater in 1880. Information was provided by Doreen Bolger Burke, Assistant Curator of American Art, Metropolitan Museum of Art, New York. For a full biography, see J. Ramirez, *Carmencita, the Pearl of Seville* (1890).

[61]St. Louis Exposition and Music Hall, no. 240; information provided by D. B. Burke.

[61a]Aanonymous, "The World's Fair: American Paintings—Melchers, McEwen, Shirlaw, Chase, Marr, Duveneck," *Art Amateur* (August, 1893), p. 56.

[62]Anonymous, "The Exhibition of the Society of American Artists," *Art Amateur* (May, 1893), p. 154.

[63]Although Roof dates this work to Chase's 1896 trip to Spain, Chase undoubtedly knew of this work through some sort of reproduction much earlier, and would have seen the actual painting as early as 1881, when he first visited the Prado Museum.

[64]*Art Amateur* (May, 1895), p. 157.

[65]*Art Amateur* (March, 1897), p. 56.

[66]Rockwell Kent, *It's Me, O Lord* (New York, 1955), p. 80.

[67]This date is based on the close resemblance of this work to *The Fairy Tale*, painted in 1892.

[68]Anonymous, "A School on the Sands," *Brooklyn Daily Eagle* (October 14, 1894), p. 9.

[69]Howard Russell Butler, "Chase—the Artist," *Scribner's Magazine* (vol. 61, February, 1917), p. 256.

[70]*Art Amateur* (April, 1894), p. 127.

[71]James W. Pattison, "William Merritt Chase, N.A.," *The House Beautiful* (February, 1909), p. 56.

[72]*Art Amateur* (February, 1894), p. 77.

[73]Anonymous, "News of the Fine Arts," *The Monthly Illustrator* (April, 1895), p. vi.

[74]*Art Amateur* (May, 1895), p. 157.

[75]*Art Amateur* (April, 1896), p. 108.

[76]*Art Amateur* (February, 1896), p. 56.

[77]S. Hartman, *Art News* (May, 1897), p. 2. Chase was familiar with the work of Degas represented in the Pedestal Fund Art Loan Exhibition in December, 1883, for he himself played a significant role in organizing this show.

[78]*Putnam's Magazine* (March, 1910), p. 757.

[79]Clipping (unidentified), artists' clipping file, New York Public Library.

[80]The painting exhibited is listed as Dieudonnée in the catalog; although it may be one of several other portraits of Dieudonnée, the date suggests it is this work.

[81]Anonymous, "The Paintings by Mr. Chase," *Academy Notes* (February, 1909), p. 149.

[82]Clara Ruge, "Amerikanische Maler," *Kunst und Kunst Handwerk* (October, 1903), p. 409.

Selected Bibliography

1. *American Impressionist and Realist Paintings and Drawings from the Collection of Mr. and Mrs. Raymond J. Horowitz.* Exhibition catalog; text by Dianne H. Pilgrim. Metropolitan Museum of Art, New York, 1973.

2. Andrews, Marietta M. *Memoirs of a Poor Relation.* New York, 1927.

3. Anonymous. "The First Exhibition of the American Painters in Pastel." *Art Journal,* Vol. 10, 1884, p. 189.

4. Anonymous. "The Chase Exhibition." *American Art Illustrator* (December, 1886), p. 99.

5. Anonymous. "Chase's Americanism." *Literary Digest* (November 11, 1916), pp. 1250–1251.

6. Anonymous. "William Merritt Chase." *The Outlook* (November 8, 1916), pp. 536–538.

7. Beal, Gifford. "The Field of Art: Chase the Teacher." *Scribner's Magazine* (February, 1917), pp. 257–258.

8. Benjamin, S. G. W. *Our American Artists.* Boston, 1886.

9. Boyle, Richard. *American Impressionism.* Boston, 1974.

10. *Chase Centennial Exhibition.* Exhibition catalog; text by Wilbur D. Peat. John Herron Art Museum, Indianapolis, 1949. (Exhibition dates, November 1–December 11, 1949.)

11. Chase, William M. "The Reward of Art." *Art Amateur* (April, 1896), p. 107.

12. Chase, William M. "Some Students' Questions Briefly Answered by Mr. W. M. Chase." *Art Amateur* (March, 1897), p. 76.

13. Chase, William M. "Talk on Art By William M. Chase." *The Art Interchange* (December, 1897), pp. 126–127.

14. Chase, William M. "The Import of Art: An Interview with Walter Pach." *The Outlook* (June 25, 1910), pp. 441–445.

15. Chase, William M. "The Two Whistlers: Recollections of a Summer with the Great Etcher." *Century Magazine* (June, 1910), pp. 219–226.

16. Chase, William M. "Talk Presented at the Metropolitan Museum of Art, New York" (January 15, 1916). Manuscript published in A. Milgrome, "The Art of William Merritt Chase," doctoral dissertation (University of Pittsburgh, 1969), pp. 106–124.

17. Chase, William M. "Painting." *The American Magazine of Art* (December, 1916), pp. 50–53.

18. Chase, William M. "How I Painted My Greatest Picture." Unidentified article, clipping file, Corcoran Gallery of Art, Washington, D.C.

19. Cikovsky, Nicolai, Jr. "William Merritt Chase's Tenth Street Studio." *Archives of American Art Journal* (vol. 16, no. 2, 1976), pp. 2–14.

20. Coon, Spencer H. "The Work of William M. Chase as Artist and Teacher." *Metropolitan Magazine* (May, 1897), pp. 307–313.

21. Cox, Kenyon. "William Merritt Chase, Painter." *Harper's New Monthly Magazine* (March, 1889), pp. 549–557.

22. DeKay, C. "Mr. Chase and Central Park." *Harper's Weekly* (May, 1891), pp. 327–328.

23. Downes, William H. "William Merritt Chase, A Typical American Artist." *The International Studio* (December, 1909), pp. xxix–xxxvi.

24. *First West Coast Retrospective Exhibition of Paintings by William Merritt Chase.* Exhibition catalog; text by Ala Story. The Art Gallery, University of California, Santa Barbara, 1964/1965 (traveling exhibition).

25. Fox, W. H. "Chase on Still Life." *The Brooklyn Museum Quarterly* (January, 1915), pp. 196–200.

26. Hoeber, Arthur. "American Artists and Their Art: II, William M. Chase." *Woman's Home Companion* (September, 1910), pp. 50–51.

27. Ishmael. "Through the New York Studios." *The Illustrated American* (February 14, 1891), p. 619.

28. Ives, A. R. "Suburban Sketching Grounds: Talk with Mr. William M. Chase, Mr. Edward Moran, Mr. Leonard Ochtman." *Art Amateur* (September, 1891), p. 80.

29. Lauderbach, Frances. "Notes from Talks by William M Chase: Summer Class, Carmel-by-the-Sea, California." *The American Magazine of Art* (September, 1971), pp. 432–438.

30. Marling, Karal Ann. "Portrait of the Artist as a Young Woman: Miss Dora Wheeler." *The Bulletin of the Cleveland Museum of Art* (February, 1978), pp. 46–57.

31. Maxwell, Perriton. "William Merritt Chase—Artist, Wit and Philosopher." *The Saturday Evening Post* (November 4, 1899), p. 347.

32. McSpadden, J. Walker. *Famous Painters of America.* New York, 1907.

33. Milgrome, A. "The Art of William Merritt Chase." Doctoral dissertation, University of Pittsburgh, 1969.

34. Morris, Harrison. *Confessions in Art.* New York, 1930.

35. *Munich and American Realism in the 19th Century.* Exhibition catalog; text by Michael Quick and Eberhard Ruhmer. E. B. Crocker Art Gallery, Sacramento, Calif., 1978.

36. Northrup, Benjamin. "From a Talk by William M. Chase." *Art Amateur* (February, 1894). p. 77.

37. Northrup, Benjamin. "Great Artist's Struggle." *Indianapolis News* (January 14, 1899), p. 9.

38. Parsons, Frank Alvah. "William M. Chase." *The American Art Student* (November–December 1916), p. 10.

39. Pattison, James William. "An Art Lover's Collection." *Fine Arts Journal* (February, 1913), p. 99.

40. Phillips, Duncan. "William M. Chase." *American Magazine of Art* (December, 1916), pp. 45–50.

41. Pisano, Ronald G. "The Teaching Career of William Merritt Chase." *American Artist* (March, 1976), pp. 26–33, 63–66.

42. Roof, Katherine M. *The Life and Art of William Merritt Chase.* New York, 1917.

43. Speed, John G. "An Artist's Summer Vacation." *Harper's New Monthly Magazine* (June, 1893), pp. 3–14.

44. *The Students of William Merritt Chase.* Exhibition catalog; text by Ronald G. Pisano. Heckscher Museum, Huntington, N.Y. and The Parrish Art Museum, Southampton, N.Y., 1973. (Exhibition dates, November 11–December 30, 1973.)

45. Van Rensselaer, M. G. "William Merritt Chase: First Article." *American Art Review* (January, 1881), pp. 91–98.

46. Van Rensselaer, M. G. "William Chase: Second and Concluding Article." *American Art Review* (February, 1881), pp. 135–142.

47. Van Rensselaer. M. G. "American Painters in Pastel." *Century Magazine* (December, 1884), pp. 204–210.

48. Van Rensselaer, M. G. "An Exhibition of Pastels." *The Independent* (May 24, 1888), p. 647.

49. *William Merrit Chase: A Benefit Exhibition for the Parrish Art Museum.* Exhibition catalogue; text by Ronald G. Pisano. M. Knoedler and Co., New York, 1976.

50. *William Merritt Chase: A Retrospective Exhibition.* Exhibition catalogue; introduction by M. L. D'Otrange-Mastai. The Parrish Art Museum, Southampton, N.Y., 1957.

Index

Edited by Dorothy Spencer

Design by Robert Fillie

Composed in ten point Palatino